THE SECRET LIVES OF MEN AND WOMEN

Also by Frank Warren:
PostSecret *and* My Secret: A PostSecret Book

THE SECRET LIVES OF MEN AND WOMEN

COMPILED BY FRANK WARREN

A POSTSECRET BOOK

REGAN

An Imprint of HarperCollins*Publishers*

> "THIS BOOK IS DEDICATED TO MY WIFE AND BROTHER"

HarperCollins books may be purchased for educational, business, or sales promotional use. For information please write: Special Markets Department, HarperCollins Publishers Inc., 10 East 53rd Street, New York, NY 10022.
For editorial inquiries, please contact Regan, 10100 Santa Monica Blvd., 10th floor, Los Angeles, CA 90067.

FIRST EDITION

Designed by Matthew Cacciola

Printed on acid-free paper
Library of Congress Cataloging-in-Publication Data has been applied for.

ISBN 10: 0-06-119875-7
ISBN 13: 978-0-06-119875-5

07 08 09 10 11 RRD10 9 8 7 6 5 4 3 2 1

"Walked out this morning, don't believe what I saw,
Hundred billion bottles washed up on the shore"

—from "Message in a Bottle" by The Police

"Therefore, since the world has still
Much good, but much less good than ill,
And while the sun and moon endure
Luck's a chance, but trouble's sure,
I'd face it as a wise man would,
And train for ill and not for good.
'Tis true, the stuff I bring for sale
Is not so brisk a brew as ale:
Out of a stem that scored the hand
I wrung it in a weary land.
But take it: if the smack is sour
The better for the embittered hour;
It will do good to heart and head
When your soul is in my soul's stead;
And I will friend you, if I may,
In the dark and cloudy day.

—from "Terence, This Is Stupid Stuff" by A.E. Housman

INTRODUCTION

WHAT IS POSTSECRET?

The PostSecret project found me in November 2004. I printed three thousand self-addressed postcards inviting people to mail a personal secret to me, anonymously. I handed out the cards to strangers and left them in public places to be discovered. From all those invitations, about one hundred artful secrets found their way to my mailbox. I thought that was the end of the project. But to this day I continue to receive every kind of secret from around the world.

I share this collection of over one hundred thousand self-made postcards with people on the Web (www.PostSecret.com), in books, and at two traveling art exhibits.

WHY DO YOU THINK PEOPLE CONTINUE TO MAIL THEIR SECRETS TO YOU?

I believe the motives are as raw and complicated as the secrets themselves.

I have tried to create a nonjudgmental "place" where every secret is treated respectfully. In this safe environment, where there is no social cost for exposing a guarded secret to millions, it might be easier for someone to confess an embarrassing story, hidden act of kindness, or sexual taboo. People have told me that facing their secret on a postcard and releasing it to a stranger have allowed

them to uncover passions, experiences, hopes, regrets, and fears that have been too painful to otherwise acknowledge.

In some cases, the postcards are so soulful and painstakingly crafted that the cards might hold deep symbolic value to the sender, perhaps a search for grace. Whatever the drive, my hope is that everyone who comes to the project learns something of others and discovers a little more about themselves.

DO YOU THINK ALL THE SECRETS ARE TRUE?

When I give talks about the project, one of the stories I tell is about a postcard that had been damaged in the mail. Part of the secret it carried had been lost. I posted it on the website with its unintended confession and later received an e-mail from the person who mailed it. (He confirmed he was the writer by knowing what was on the back of the card.) He told me he had invented the original secret but went on to say, "The new altered meaning of the secret on the card is true to me."

I think the postcards work like art. So to ask me if the postcards are true or false is like asking if a painting or sculpture in a museum is fiction or nonfiction.

DO YOU HAVE A FAVORITE SECRET?

Yes, but I never had a chance to see it. I learned about it in an e-mail that read, in part, *I thought long and hard about how I wanted to word my secret and I searched for the perfect postcard to display it on. After I had created my postcard I stepped back to admire my handiwork. Instead of feeling relieved that I had finally got my secret out, I felt terrible instead. It was right then that I decided that I didn't want to be the person with that secret any longer. I ripped up my postcard and I decided to start making some changes in my life to become a new and better person.*

I like to imagine what this postcard revealed and the story behind it.

WHAT HAVE YOU LEARNED FROM ALL THE SECRETS YOU HAVE SEEN?

Courage can be more important than training or technique in creating meaningful art; a lot of us pee in the shower; and lastly, men have secrets but women keep the best secrets.

Whenever I fly I put hopeful messages in the seat pocket for the next passengers to read.

– Utah

To the person who mailed the postcard that read, "The thing I hate most about myself is that I'm too lazy to change the things I hate," I read your secret and cried. I decided to look at myself and see what my problem was. More than being lazy, I realized it was about fear. I was afraid of trying my hardest and still not succeeding. But then I realized I was already living my worst case scenario by not even attempting to move forward. Today, I decided fear and laziness would not rule my life. I hope knowing you helped someone will help you too.

– New Mexico

Dear Mother-in-Law,

If you tell me how good the deals are at Costco one more time, I will burn the place down. No jury would convict me.

Love,___

Your devoted Daughter-in-Law

P.S. I hate those giant muffins. I don't care if a dozen costs less than five dollars. I am throwing them away as soon as you leave.

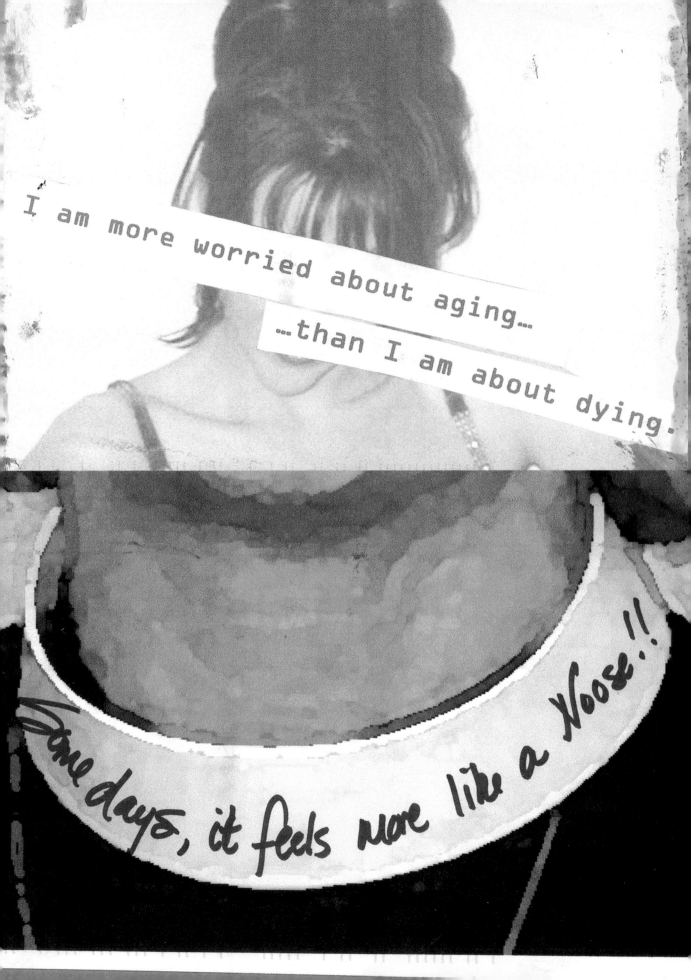

I am more worried about aging...

...than I am about dying.

Some days, it feels more like a NOOSE!!

Arising from a quiet, agricultural history, Oklahoma has become a dynamic state growing rapidly with Aerospace, Communication, Technology and Transportation industries.

I've been with my wife for 20 years and she doesn't know who I am.

Post Secret
13345 copper ridge Rd.
Germantown, Md.
 20874

Performance anxiety has ruled my sex life.

THE GEODUCK (Panope Generoso)
Native of Puget Sound, often reaches great size. Geoduck Hunting is a very popular sport in the neighborhood of Hood Canal · Washington

© J Boyd Ellis
Arlington, Wn.

I think I hAve
breast CANCER...

buT i'm too
scarEd to gET
CheCked

WHEN I WAS MARRIED
I PUT PULVERIZED
SLEEPING PILLS IN
MY HUSBAND'S FOOD
SO HE WOULD GO TO
SLEEP AND
LEAVE ME ALONE

IT
NEVER
WORKED

I wish I could remember
who my mom was before
her disease stole her
mind

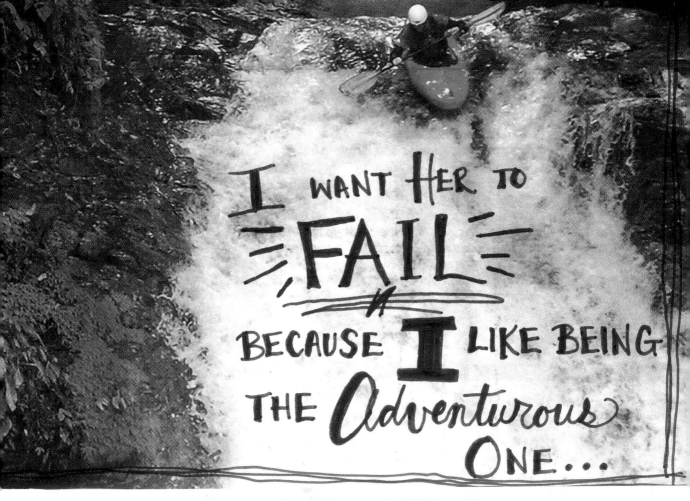

I WANT HER TO FAIL BECAUSE I LIKE BEING THE *Adventurous* ONE...

He scares me when we go fast...

But I don't want to tell him....

I want him to think I am fearless like he is....

I often wonder what it would have been like if I chose the "other man" instead of my husband.

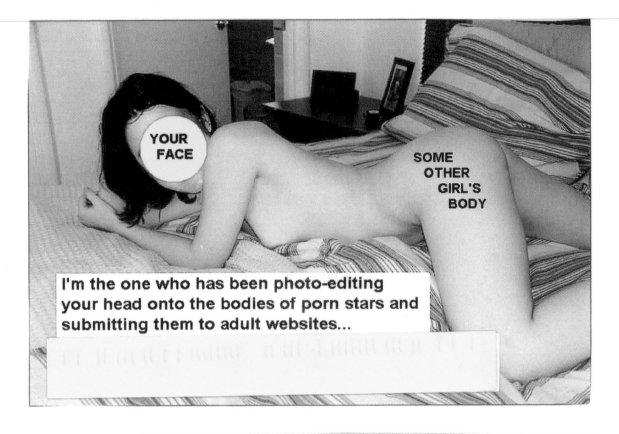

i tell people
that i don't want kids...

i don't tell them
that i'm afraid
of passing on
my mental illness
to a perfect
child.

CERTAIN MEDS MAY ALTER EFFECT
OF BIRTH CONTROL PILLS. ASK
YOUR RPH OR DR.

DO NOT USE IF PREGNANT OR
SUSPECT YOU ARE PREGNANT OR
ARE BREAST FEEDING.

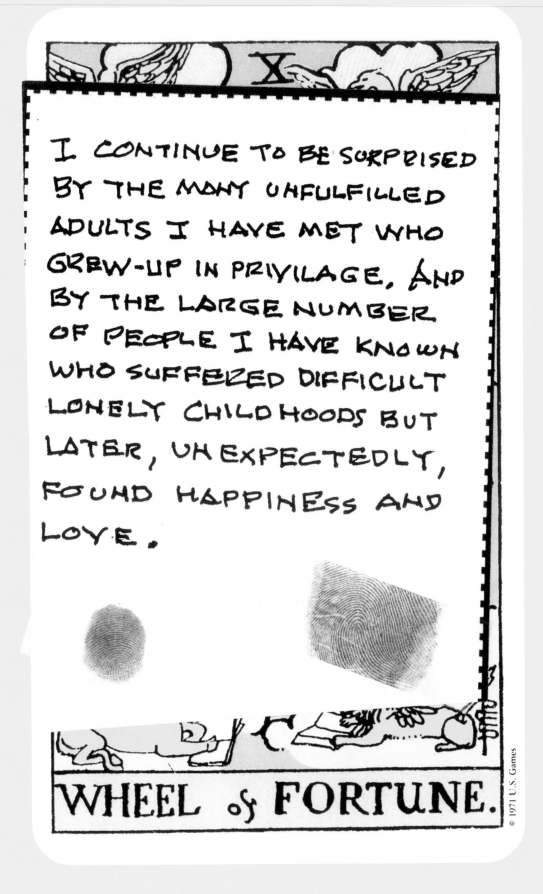

I CONTINUE TO BE SURPRISED BY THE MANY UNFULFILLED ADULTS I HAVE MET WHO GREW-UP IN PRIVILAGE, AND BY THE LARGE NUMBER OF PEOPLE I HAVE KNOWN WHO SUFFERED DIFFICULT LONELY CHILDHOODS BUT LATER, UNEXPECTEDLY, FOUND HAPPINESS AND LOVE.

WHEEL of FORTUNE.

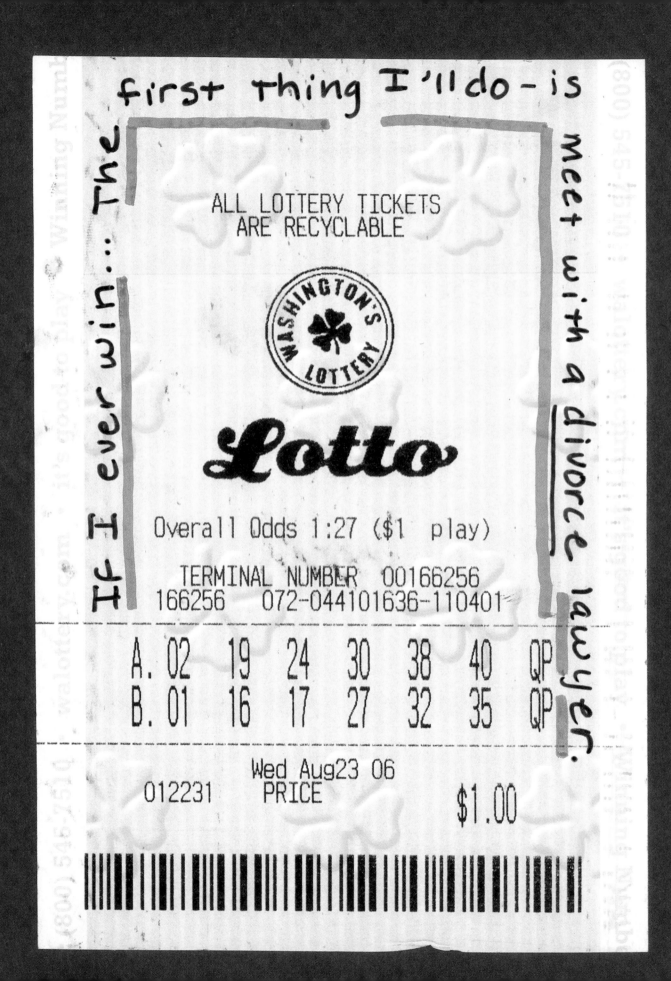

The first thing I'll do - is

If I ever win... The

meet with a divorce lawyer.

ALL LOTTERY TICKETS
ARE RECYCLABLE

WASHINGTON'S LOTTERY

Lotto

Overall Odds 1:27 ($1 play)

TERMINAL NUMBER 00166256
166256 072-044101636-110401

A. 02 19 24 30 38 40 QP
B. 01 16 17 27 32 35 QP

Wed Aug23 06
012231 PRICE $1.00

July

S	M	T	W	T	F	S
						1
2	3	4	5	6	7	8
9	10	11	12	13	14	15
16	17	18	19	20	21	22
23	24	25	26	27	28	29
30	31					

II

Tuesday
July

- Talk to Sally about her work performance

CC

- Scheldules

- Enterviews

- Budget Meeting
- Staff cuts?

I write fake notes on my desk calendar for my emplyees to find just to see how fast the news spreads!

1

I'm 46, I'm gay and I still have not told my family. As a boy we used to be so close. Now I feel so distant and lonely.

EVERY TIME THERE'S A SHOOTING ON THE NEWS

I EXPECT TO HEAR HIS DESCRIPTION FOR A SECOND...

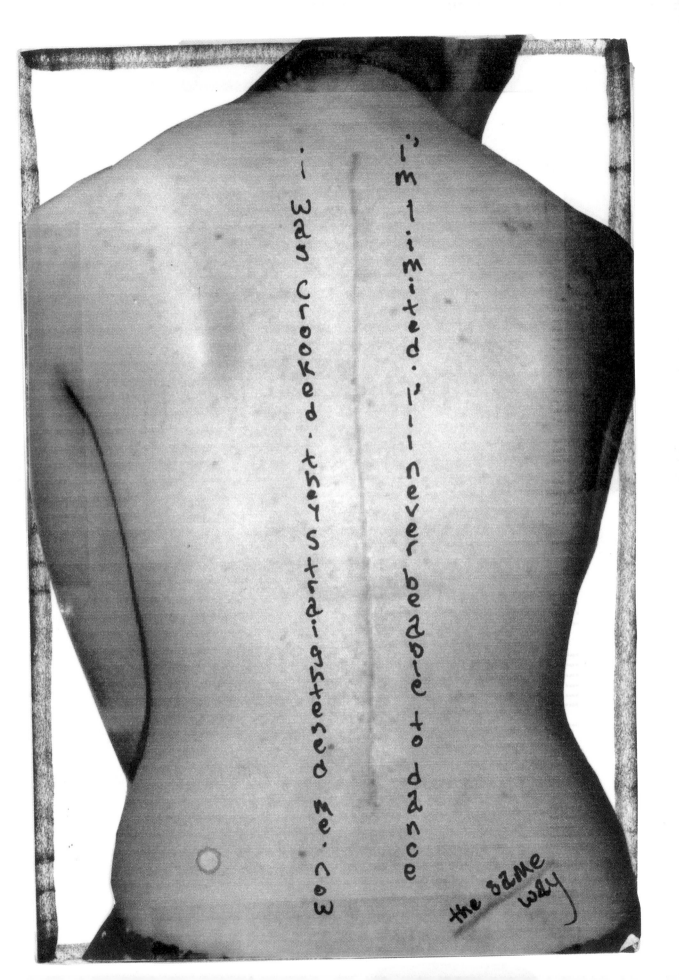

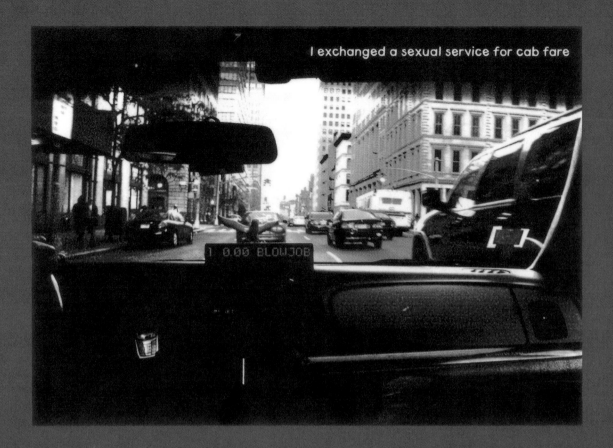

I exchanged a sexual service for cab fare

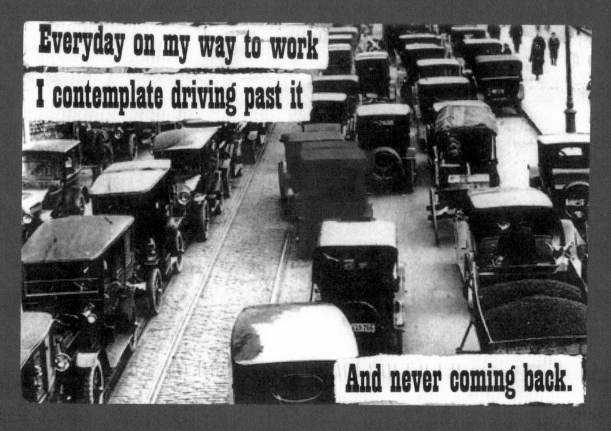

Everyday on my way to work
I contemplate driving past it
And never coming back.

← plastique

I found out that the stone on my engagement ring is FAKE. My husband doesn't know (it was in his family), & I can't tell him bc he'd feel awful. Now I feel like everyone who knows anything about jewelry is staring at this plastic rock!

(and bc it's my engagement ring, I have to wear it EVERY SINGLE DAY).

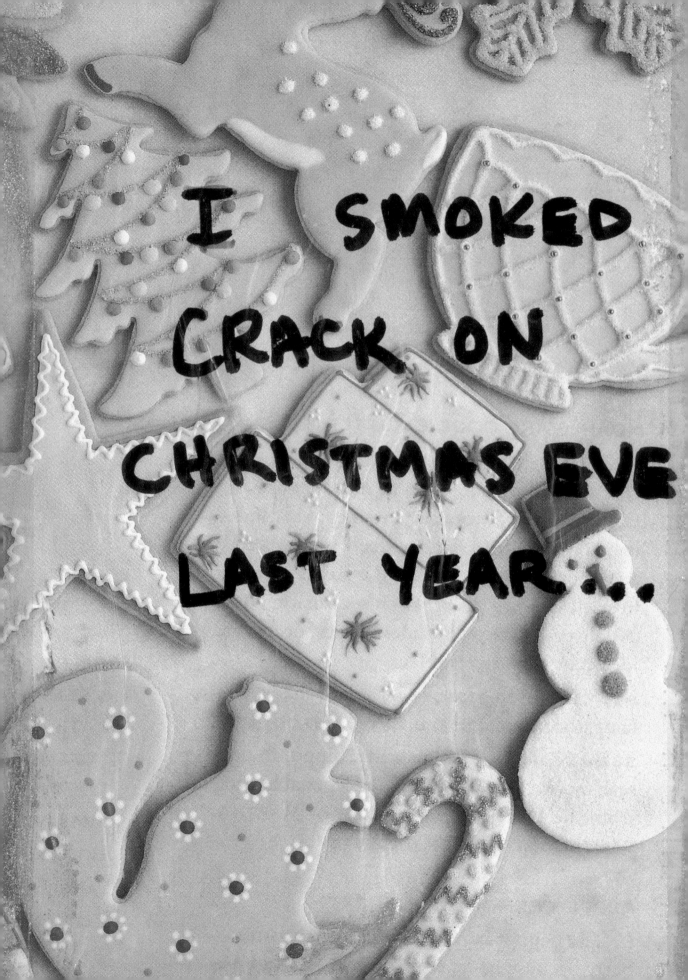

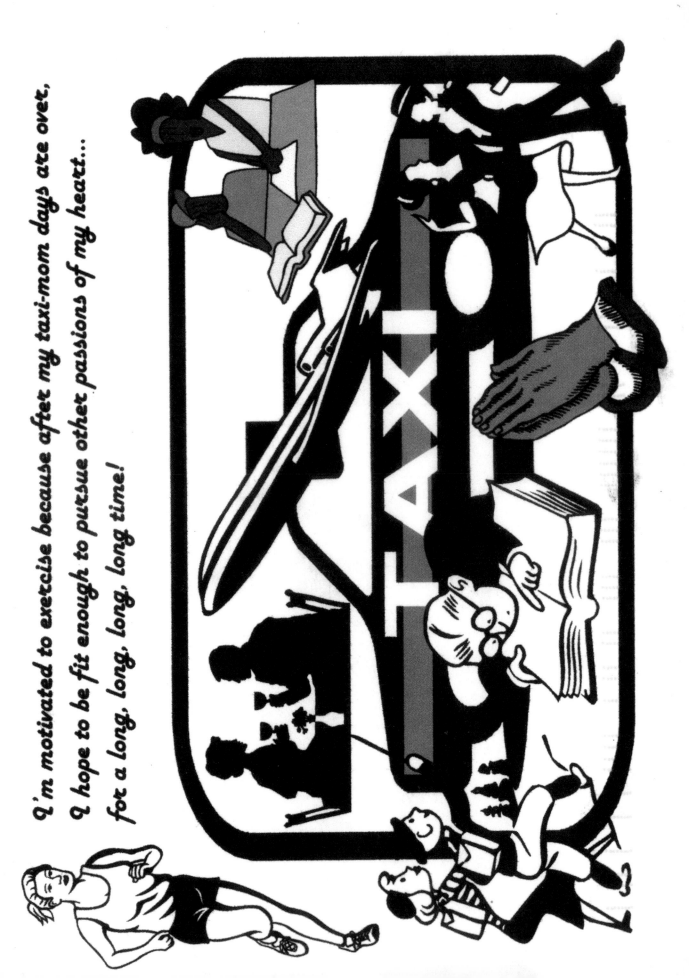

I'm motivated to exercise because after my taxi-mom days are over, I hope to be fit enough to pursue other passions of my heart... for a long, long, long, long time!

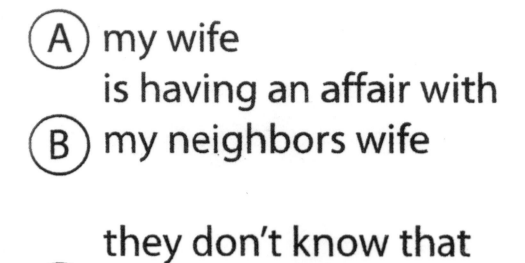

I knew I was gay

on our wedding day

but wanted children

and feared aids

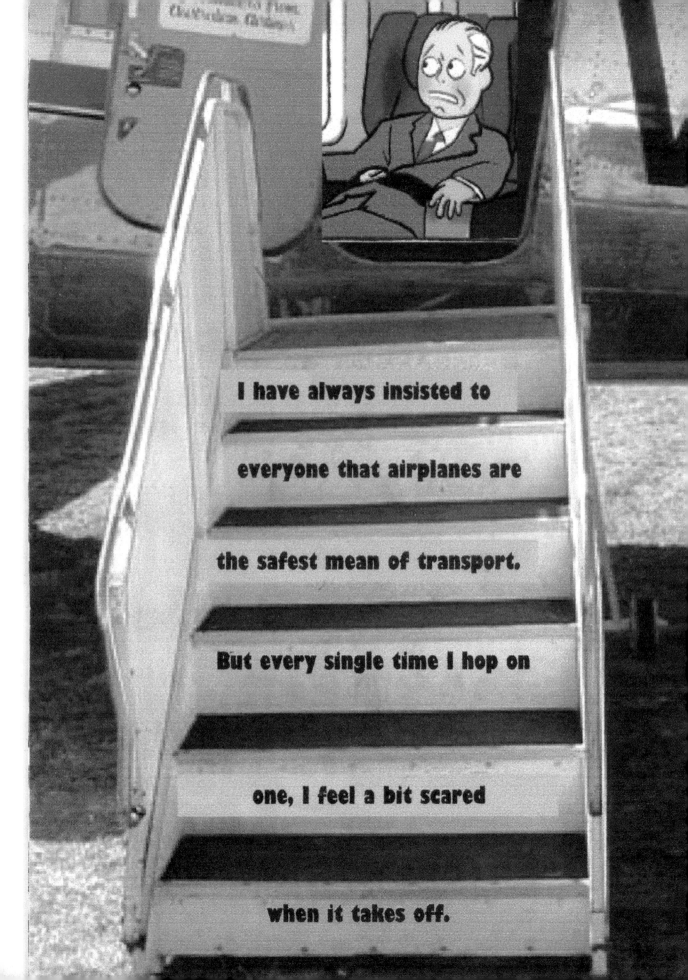

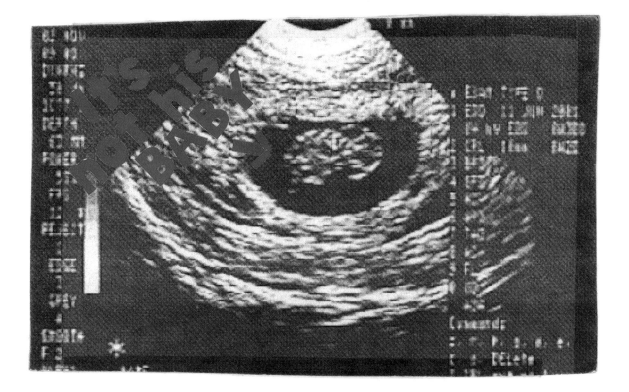

my entire life
has been a lie
by omission.

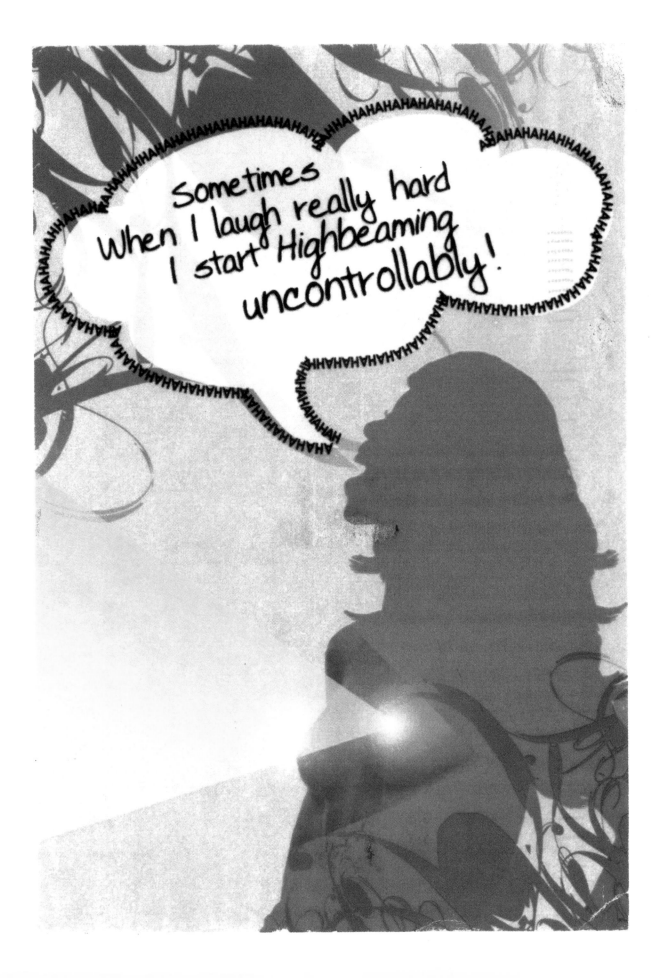

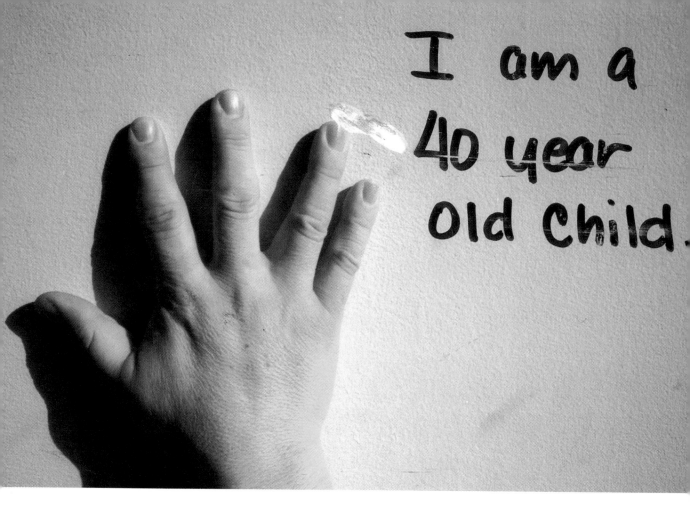

I am a 40 year old child.

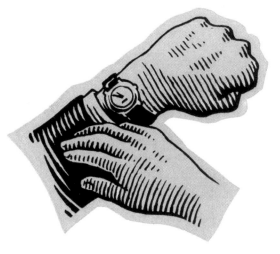

I only wear watches with numbers
because I can't read dots or
roman numbers.

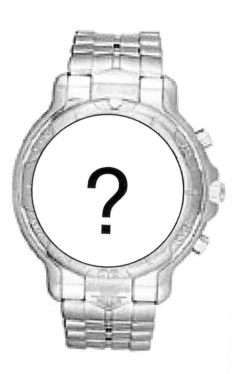

verytime the new
o-worker squeezes
y arm & smiles,
just want to
ake her down
ight there,
egardless of
onsequences.

I am so silly
on the
inside

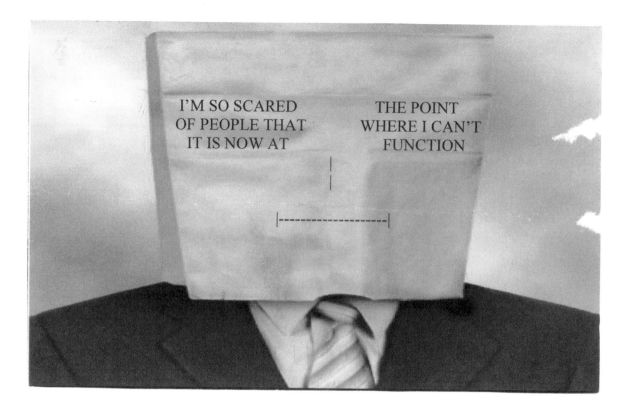

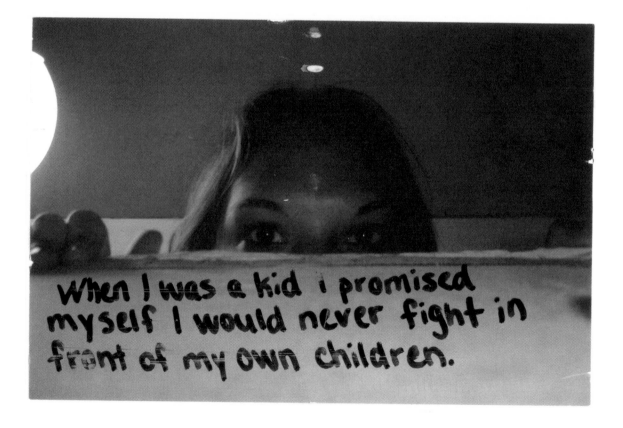

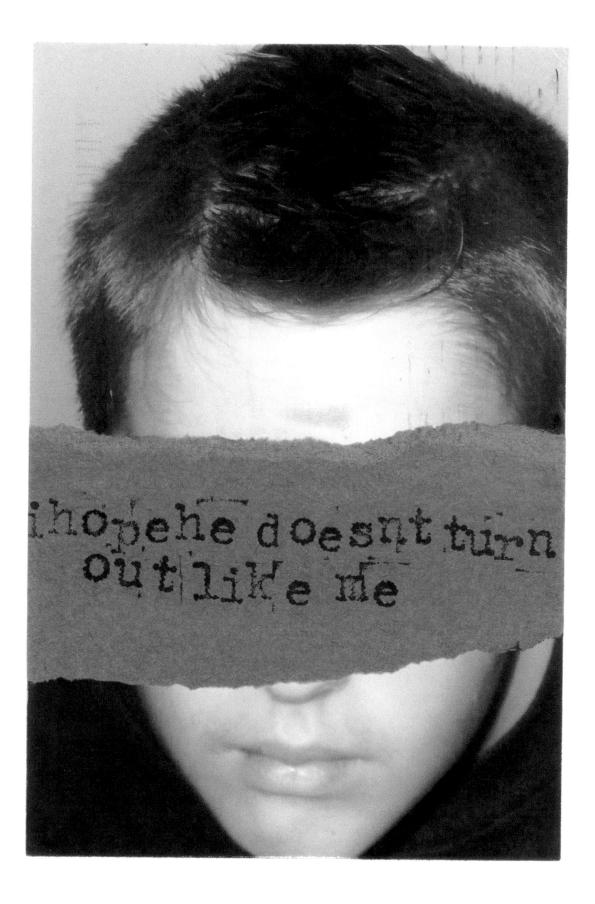

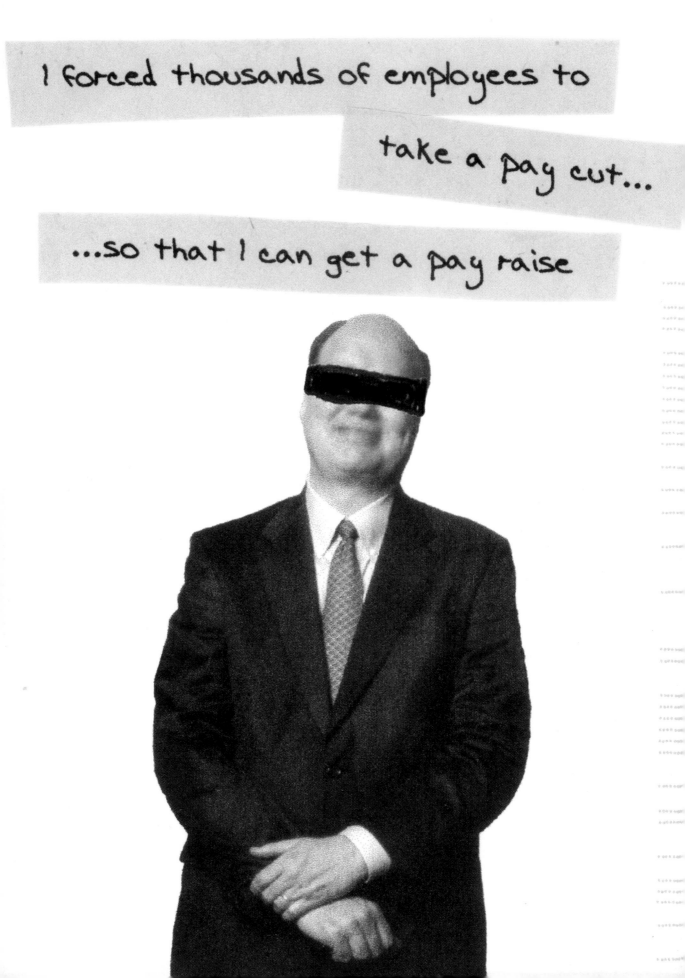

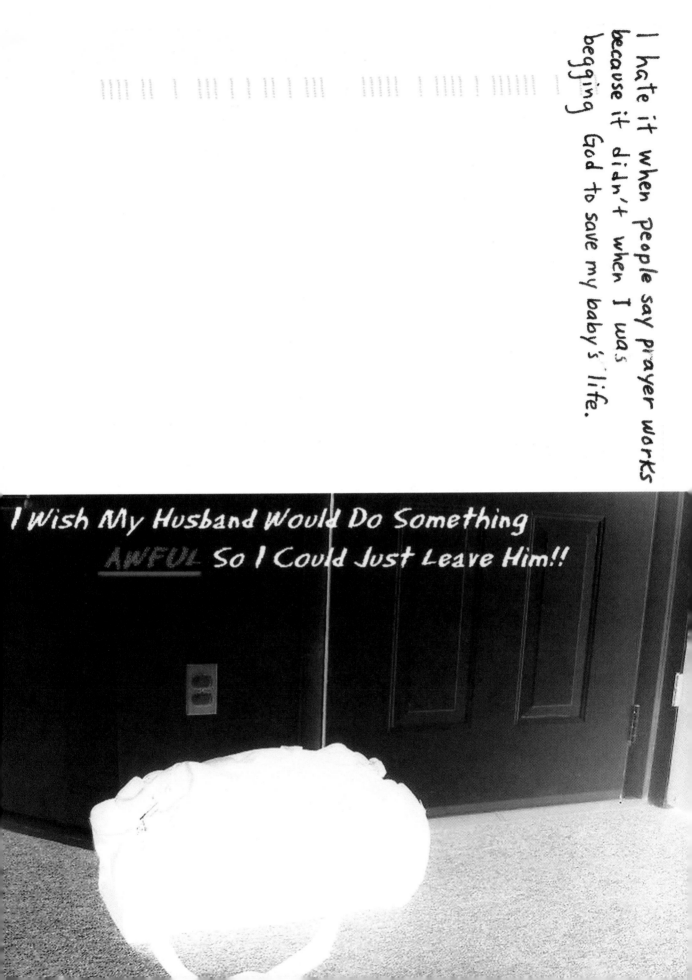

I hate it when people say prayer works because it didn't when I was begging God to save my baby's life.

I Wish My Husband Would Do Something AWFUL So I Could Just Leave Him!!

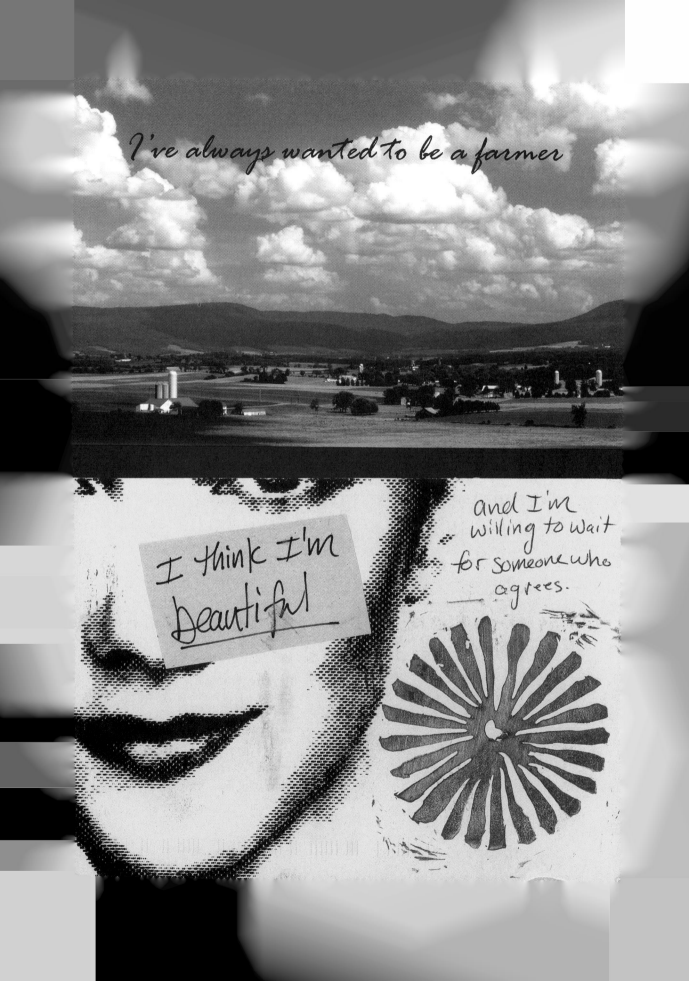

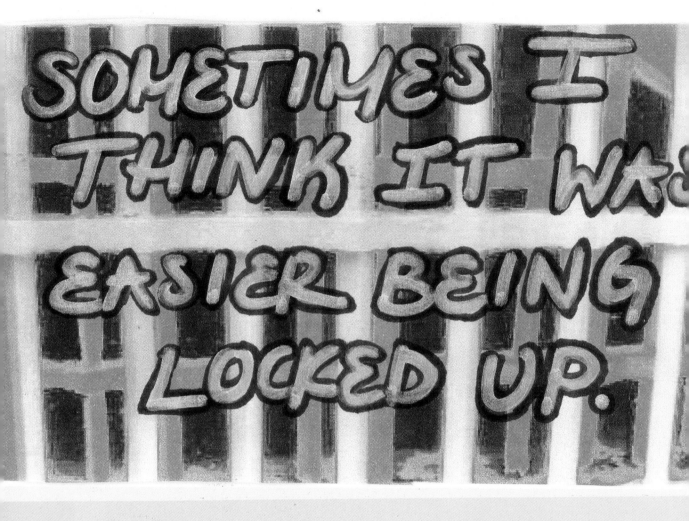

SOMETIMES I THINK IT WAS EASIER BEING LOCKED UP.

I <u>HATE</u> WHERE YOU WORK.

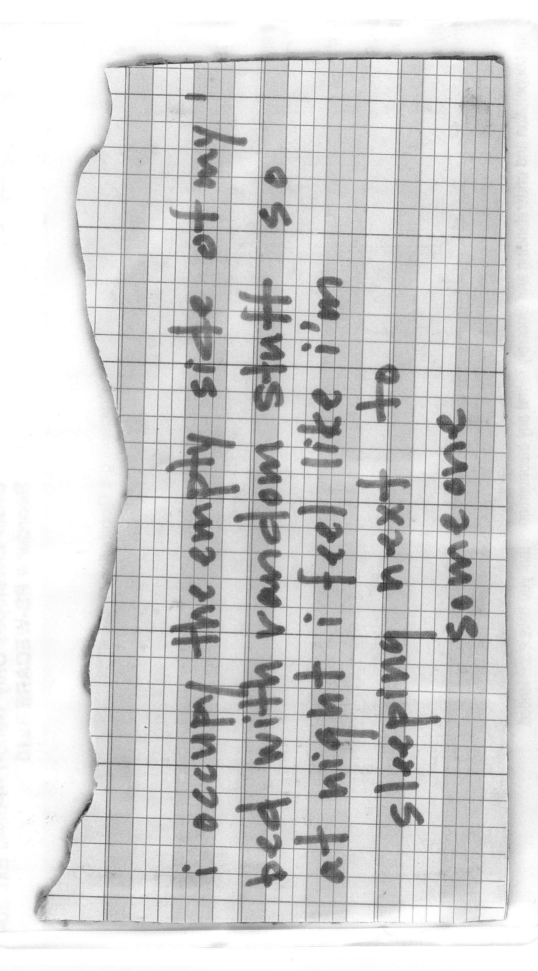

i occupy the empty space of to my !

bed with random stuff as

night i feel like i'm in

next laurels of

someone

Reservoir Dogs is my
Favorite movie

But since I am a married mother of 3
I tell everyone it's Steel Magnolias

I GAVE UP MY DREAM BECAUSE
OF ONE
BAD TEACHER

Some of the secrets really cause me to sit back and say a quick prayer for whoever wrote them. Some of the secrets make me laugh hysterically. Some of the secrets make me think: "I wonder if so and so posted that secret," and some of the secrets make me think: "WOW! I'm not alone."

– England

Every single person has at least one secret that would break your heart. If we could just remember this, I think there would be a lot more compassion and tolerance in the world.

– Mississippi

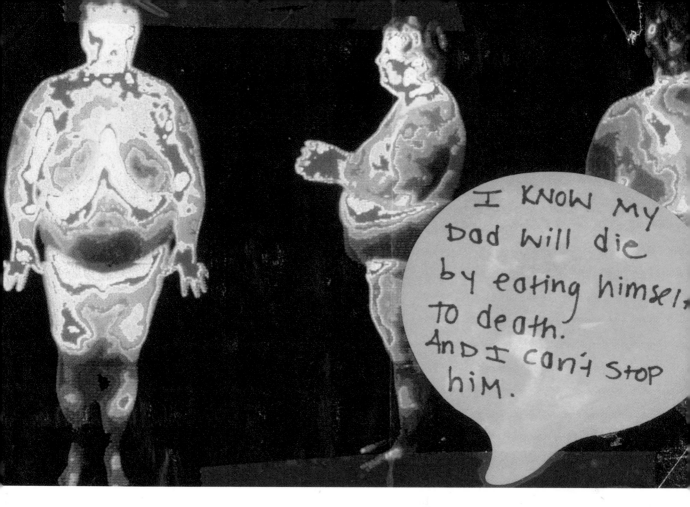

My husband likes to cook, but he doesn't like parties.

Sometimes he'll make me food to take to a party.

When he does, I dump out half of the leftovers before I get home so he'll think people ate more than they actually did.

When I'm in public washrooms and nobody else is around, I stand 3 or 4 feet back from the urinal.

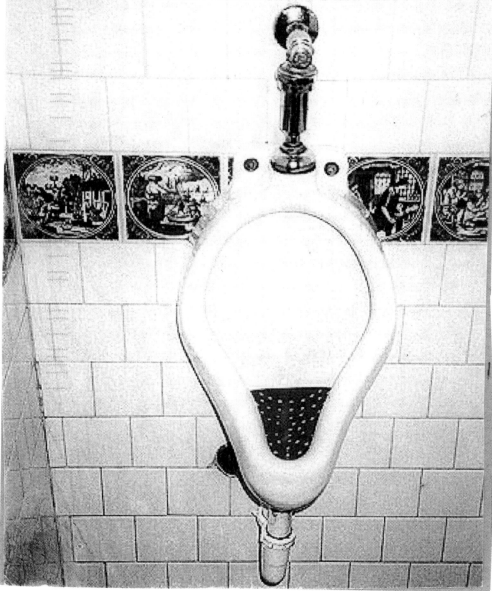

I don't know how to go back to

<u>God</u> ...And

I want to more than anything else in the world...

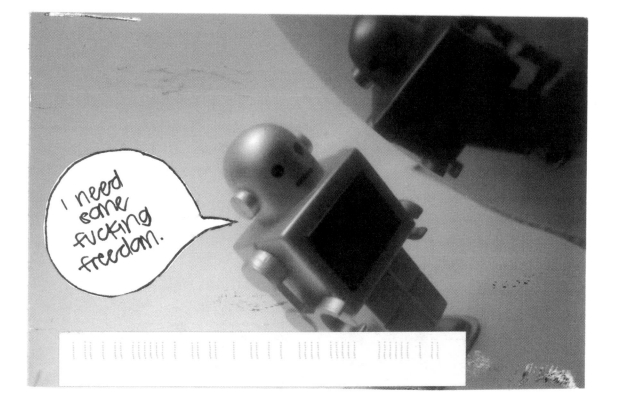

I let my kids listen

to

PUNK
MUSIC

when my
husband
isnt in
the
car
w/ us.

(they are
ages 8,
10 & 11)

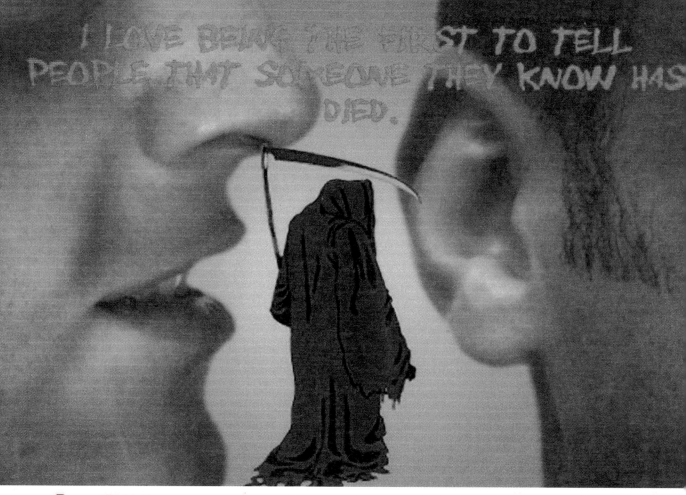

I LOVE BEING THE FIRST TO TELL PEOPLE THAT SOMEONE THEY KNOW HAS DIED.

Sometimes...
 when I'm driving home from work
I switch the ring I wear on my right ring finger
 to my left ring finger
and imagine what it would be like to have someone
 waiting for me at home.

I am a respected staff member of the school where I work.

Nobody there knows that I have pierced nipples.

MY HUSBAND ONLY LOVES ME
WHEN HES DRUNK

I will never
forgive myself
for letting my
girlfriend get
an abortion.

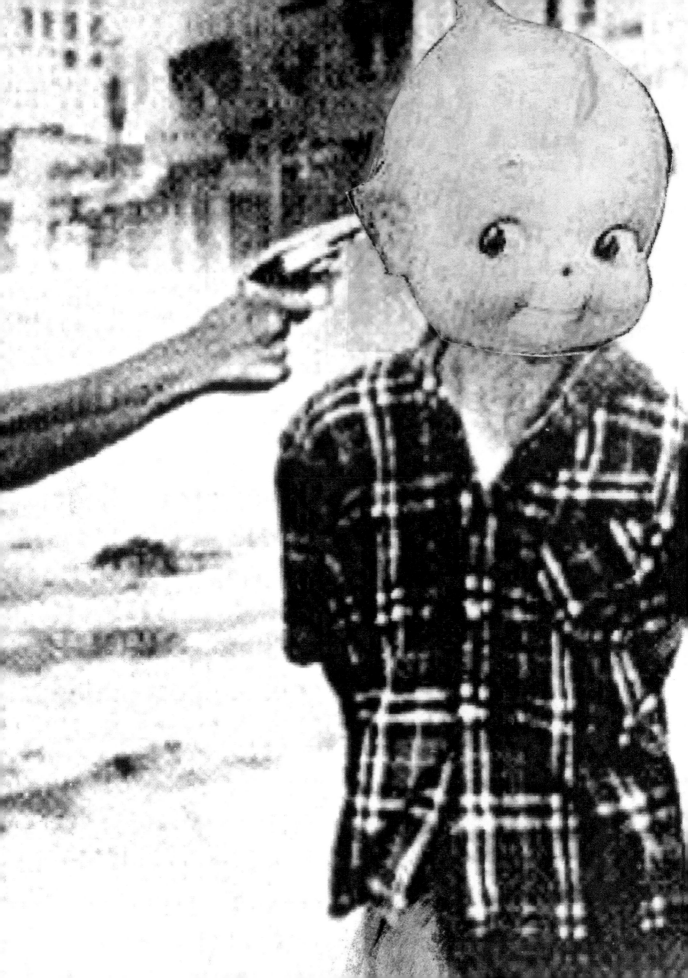

When I write a To-Do list...
I write "Starve Yourself" but i abbreviate it S.Y. so no one knows

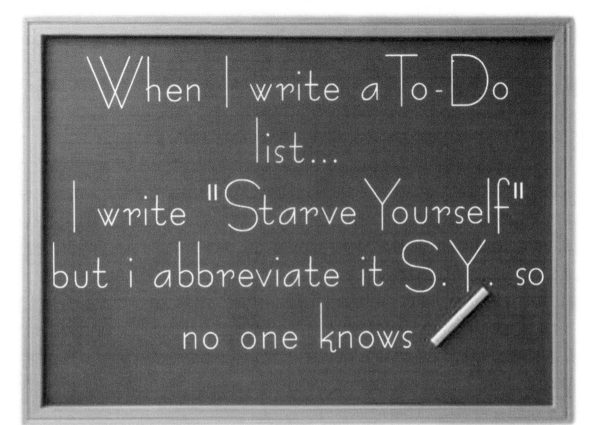

I HAVE A SICK NEED FOR ABANDONMENT

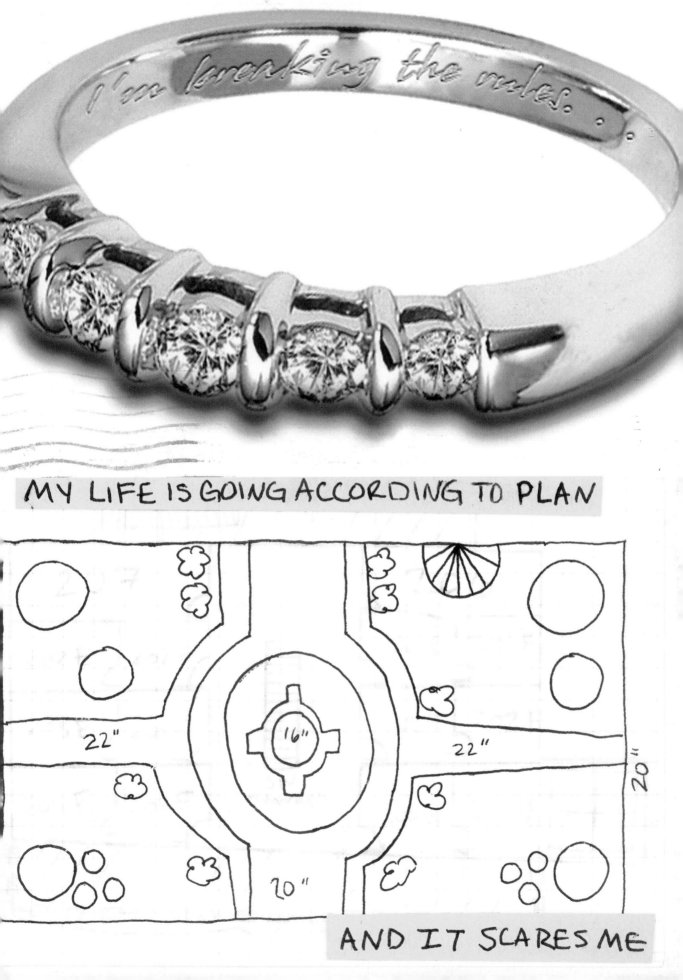

I'm breaking the rules.

MY LIFE IS GOING ACCORDING TO PLAN

22" 16" 22" 20"

20"

AND IT SCARES ME

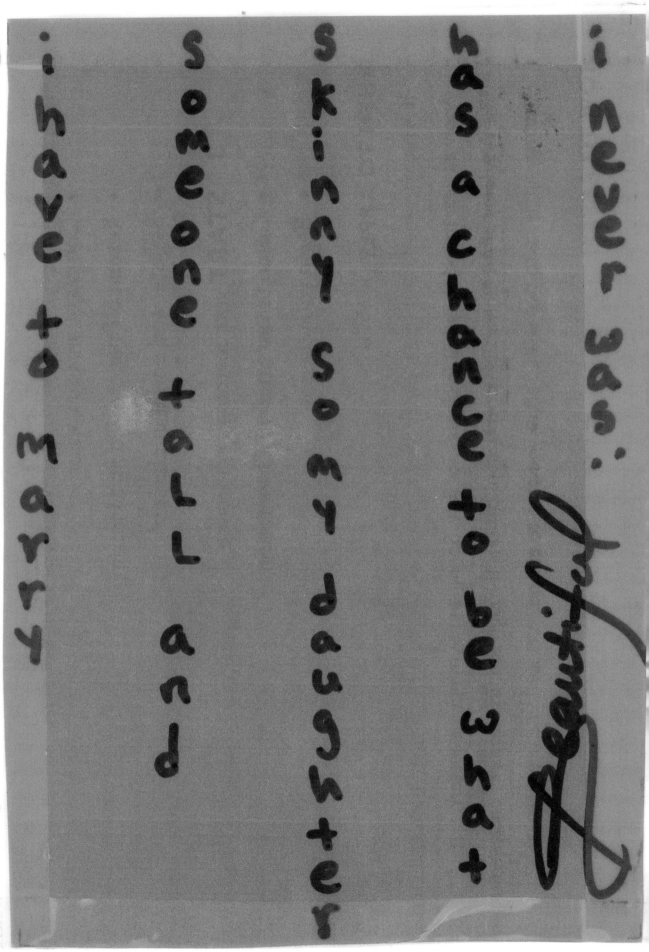

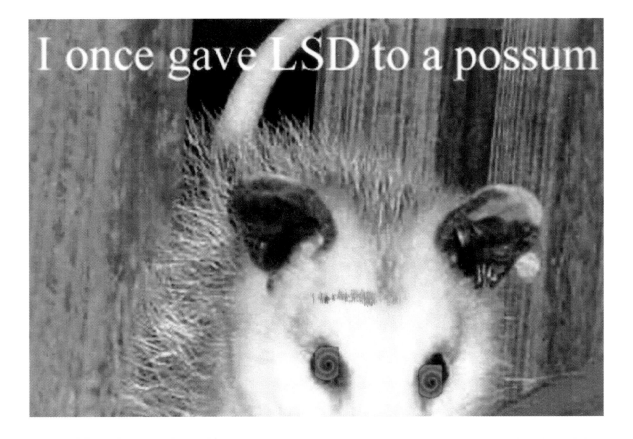

I once gave LSD to a possum

I MAILED HER AN ANONYMOUS NEWSPAPER ARTICLE ABOUT INFIDELITY SO THAT SHE WOULD BE SUSPICIOUS.

I've wanted to die
For 36 years...

but I know I'll spend
eternity in Hell

At times I just don't know
how you could be anything but beautiful
I think that I was made for you
and you were made for me . . .

Mr. and Mrs. C **on our first date**

request the pleasure of your company

at the marriage of their daughter

J **I told him**

to

Sc **that I had genital herpes**

son of **he loved me anyway**

this July we will *Celebrate*

Saturday, the nineteenth of Ju

nineteen hundred and eighty-six

at six-thirty in the evening

our 20 year anniversary

306 South First Avenue

thank you for loving me.

eption immediately following **Any way.**

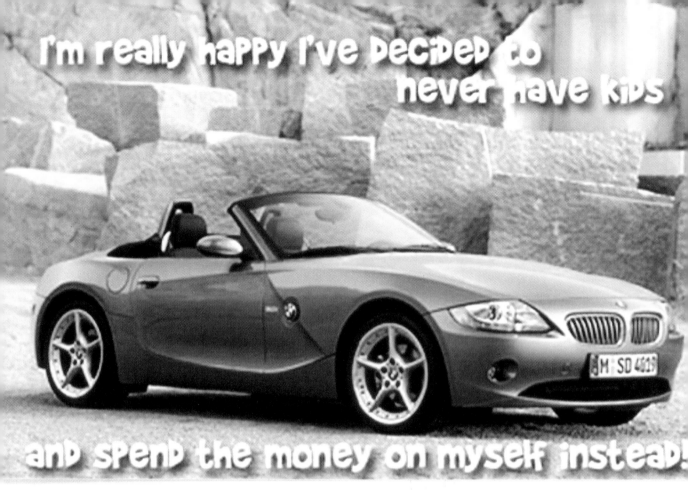

I'm really happy I've decided to never have kids

and spend the money on myself instead!

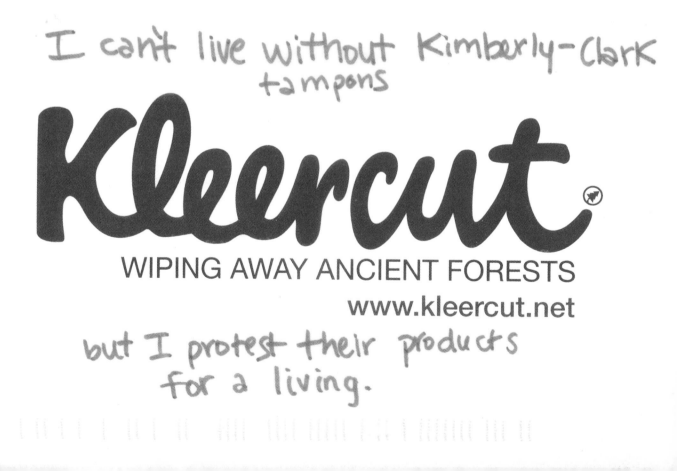

I can't live without Kimberly-Clark tampons

Kleercut

WIPING AWAY ANCIENT FORESTS

www.kleercut.net

but I protest their products for a living.

I didn't take a pill last night.
Even if you leave me,

SUN MON TUE WED THU FRI SAT
START
YASMIN® 28

I'll have paRt of you to love
foReveR.

Sometimes I wish I could use the techniques of a
Mafia Godfather in my personal & professional life.

I've watched CSI so
Many times I've thought of
That The Perfect way to kill
him. And never be
found out
A
CRIME SCENE DO NOT CROSS
CR

I committed adultery hoping it would be more than just a fuck.

I was wrong!

i wish i had known she was dying.

Don't fear that I'll
tell her about the affair
before your wedding.

Fear that I'm waiting
to tell her
after the wedding.

If my family found out...

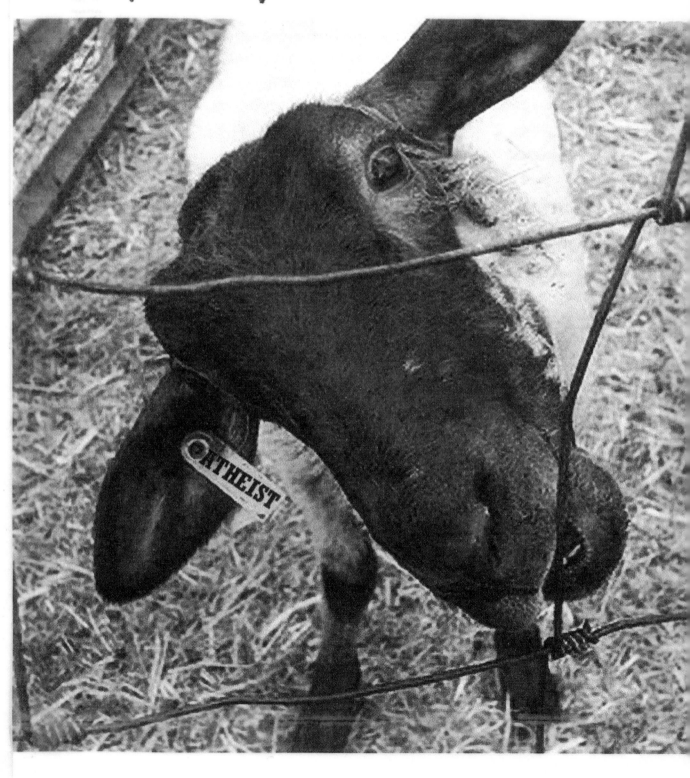

...they would disown me.

I sent in a secret at one point, but it never made it up on the website. Yet every week I look for it, and in the process, found one of my secrets on someone else's card. "One day I hope to have the courage I need to tell you that you saved my life." That card made me realize the reason I don't have the courage to tell him he saved my life is because I don't know how to say "thank you" if I do admit it. But an inadequate thank you is better than none. I'm going to talk to him tomorrow. Thank you for helping me find my courage and I wish the same to you.

– Japan

I have a suicide prevention hotline programmed in my cell phone under the name "Erin."

– Montana

MOTHER NEVER GAVE ME JUST [ONE] ATTA GIRL

she had no words

Now I have to do it myself it is so HARD

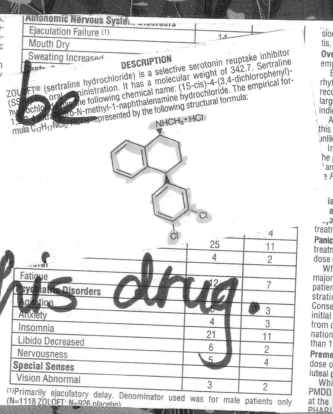

I can't be happy without this drug.

I left your husband.
I've never met you.
Part of me is tempted
to mail you all of the
receipts of the affair.

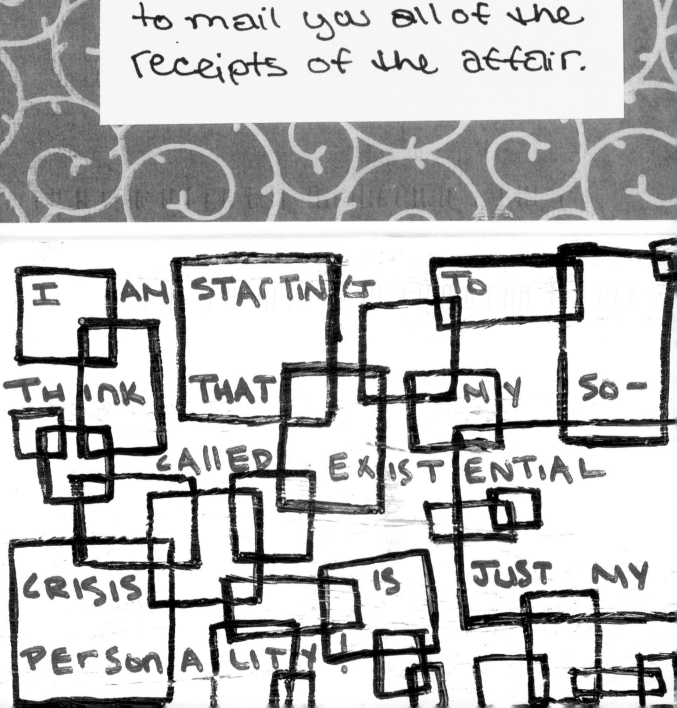

I AM STARTING TO THINK THAT MY SO-CALLED EXISTENTIAL CRISIS IS JUST MY PERSONALITY!

You will never know that you absolutely changed my life. Thank you.

I bought an expensive sewing machine just to make my sister jealous

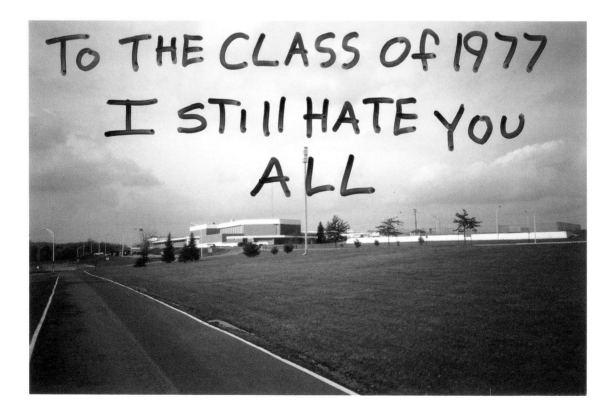

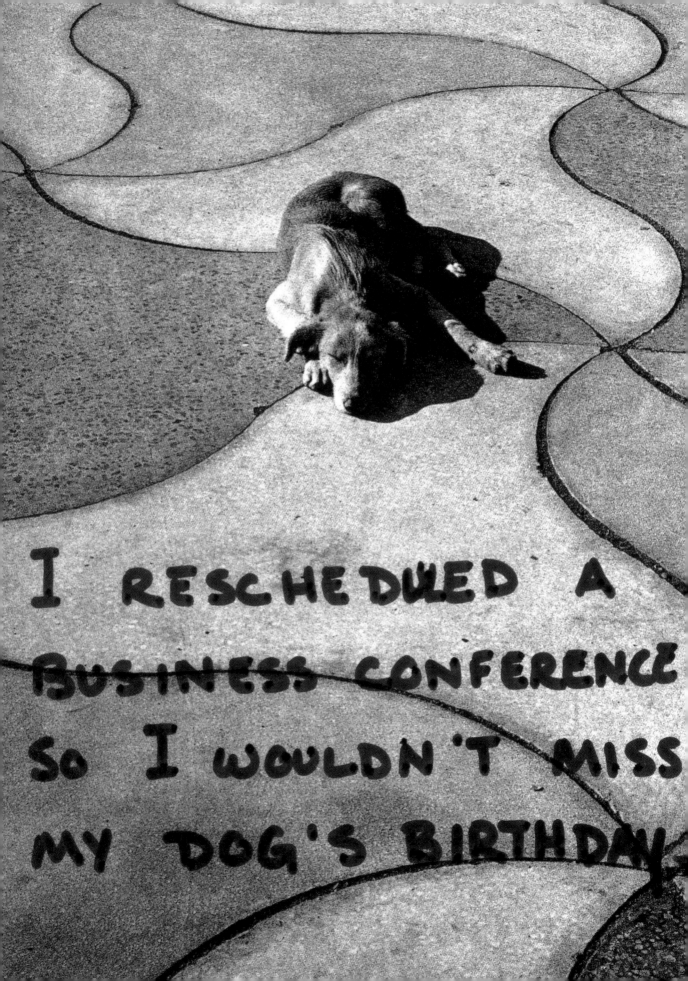

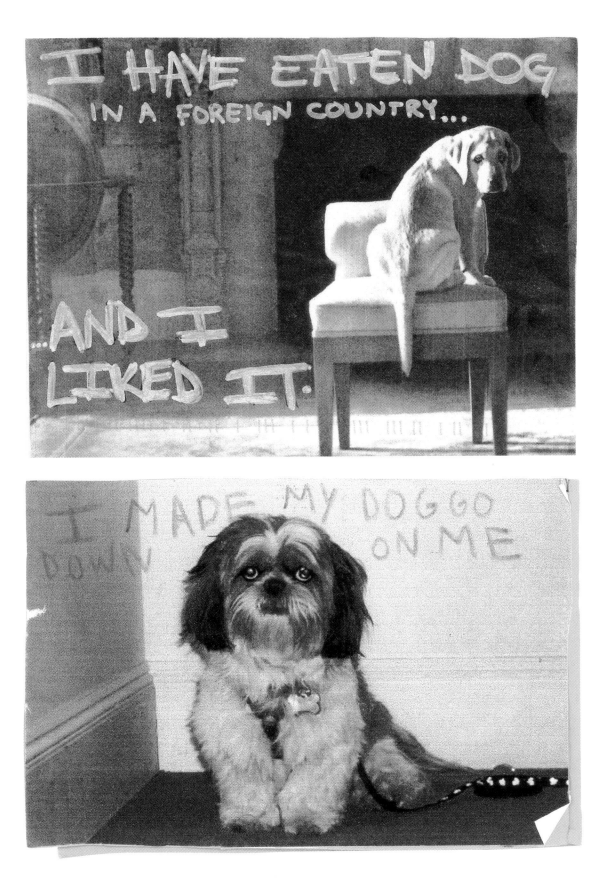

I'm terrified that my sister is going to hurt herself on purpose

...and i don't know how to help her.

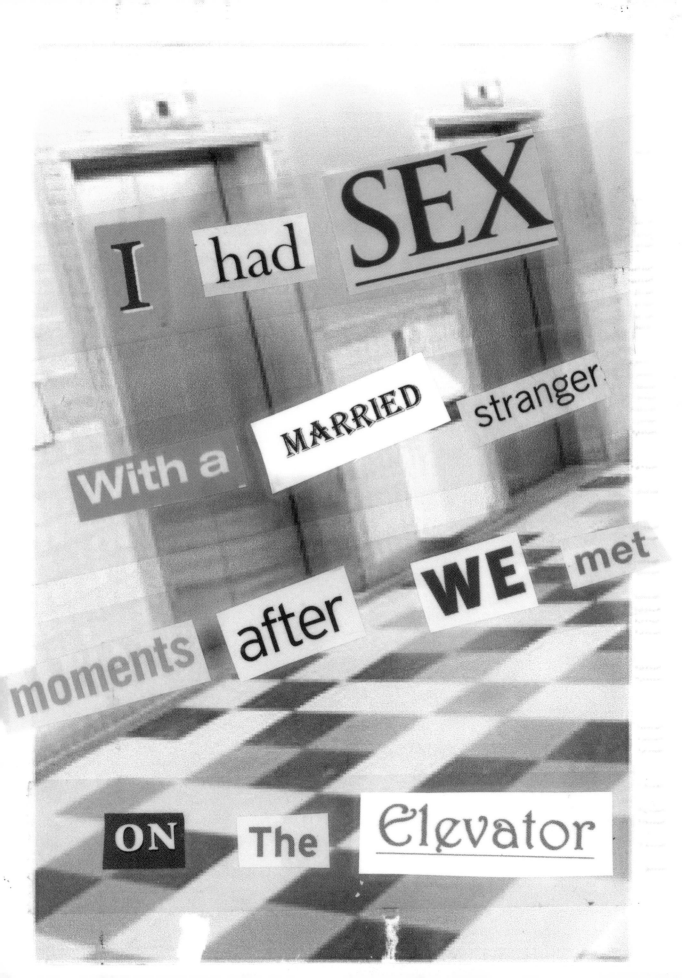

Sometimes I feel like I lied to you when I said I was ok with not having children....

Wish I would STOP buying you cards I will never, ever, ever SEND.

We have the best. "How did you meet?" Story. I know everyone is envious. It feels great.

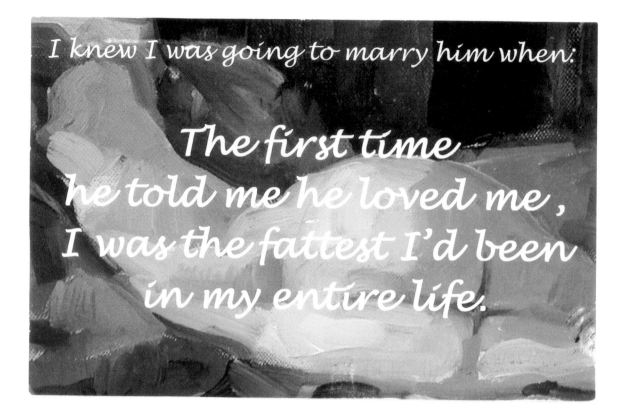

I knew I was going to marry him when:

The first time
he told me he loved me,
I was the fattest I'd been
in my entire life.

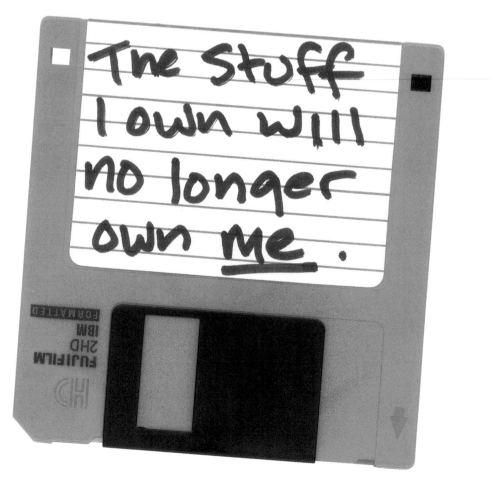

The stuff
I own will
no longer
own me.

I've prayed to God every night of my 25 years of marriage and my athiest husband has absoulutely no idea!

I often fantasize
about killing many
people attacking
me or my family
and friends,
so that it
would be
justified
self-defense or
heroism.

FANTASTIC, AMAZING THINGS CAN STILL HAPPEN, EVEN TO A DULL OLD FELLOW LIKE ME...

I saved the life of someone
I truly HATE.

Nobody will ever know that
it was ME.

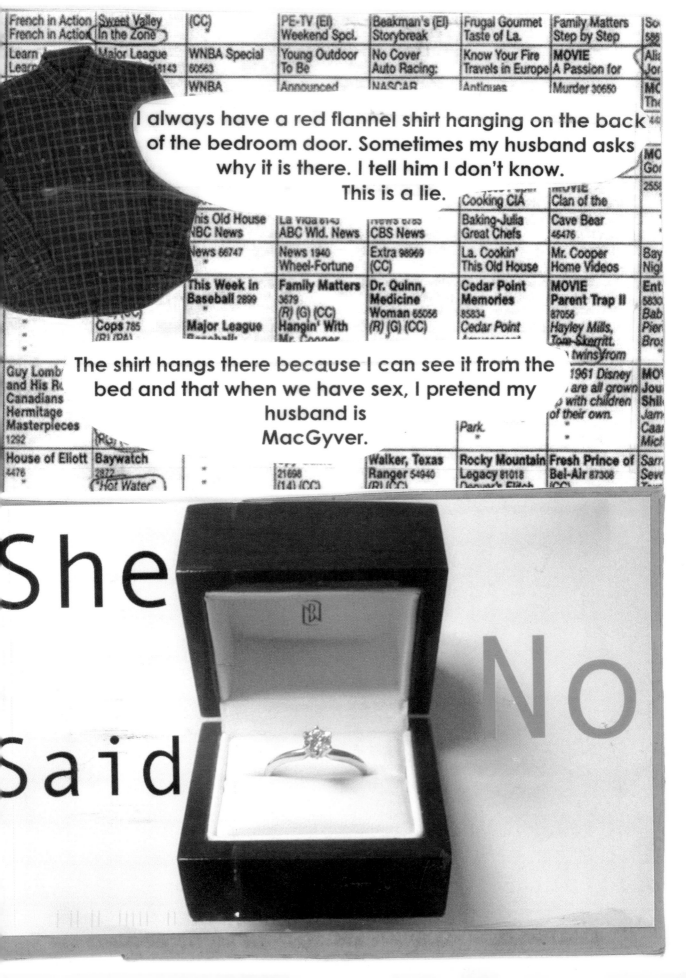

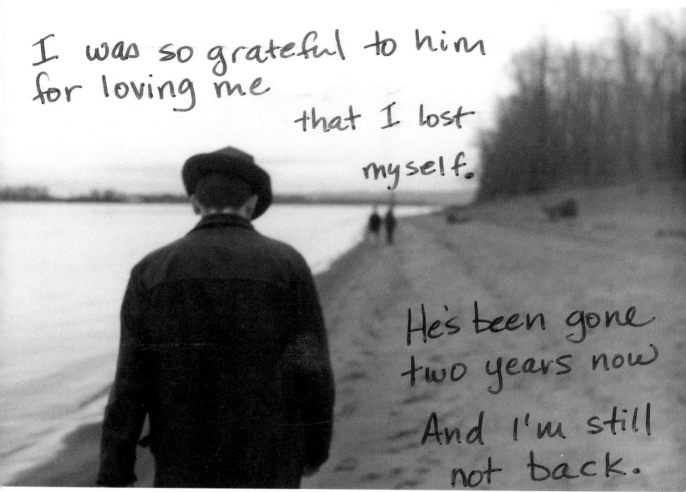

I was so grateful to him for loving me that I lost myself.

He's been gone two years now And I'm still not back.

DRIVER'S LICENSI
LIC#: 12345678
CLASS: OPERATOR

HAIR: BROWN
EYES: BLUE
SEX: FEMALE
DOB: 08/30/1962

I ID MIDDLE-AGED WOMEN BECAUSE I LIKE TO THINK IT MAKES THEIR DAY!

I'm hoping my life will Magically change when I have Straight Teeth

When I was 16 I had an abortion

When I was 33 I had a miscarriage

I think God was punishing me.

I no longer feel the awkward obligation to fill silent spaces with mindless self-centered chatter.

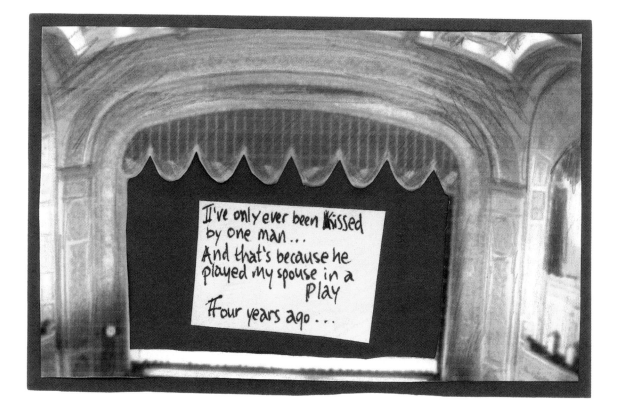

I got tired of being pregnant And broke my water so the baby would be born two weeks early.

Recipe for _____

My family's
secret ingredient
is almond extract

I told her I caught him
when he rolled
off the changing table
but I was picking him up
off the floor

I didn't know
he could have died
I can still see
his terrified eyes
I was only four

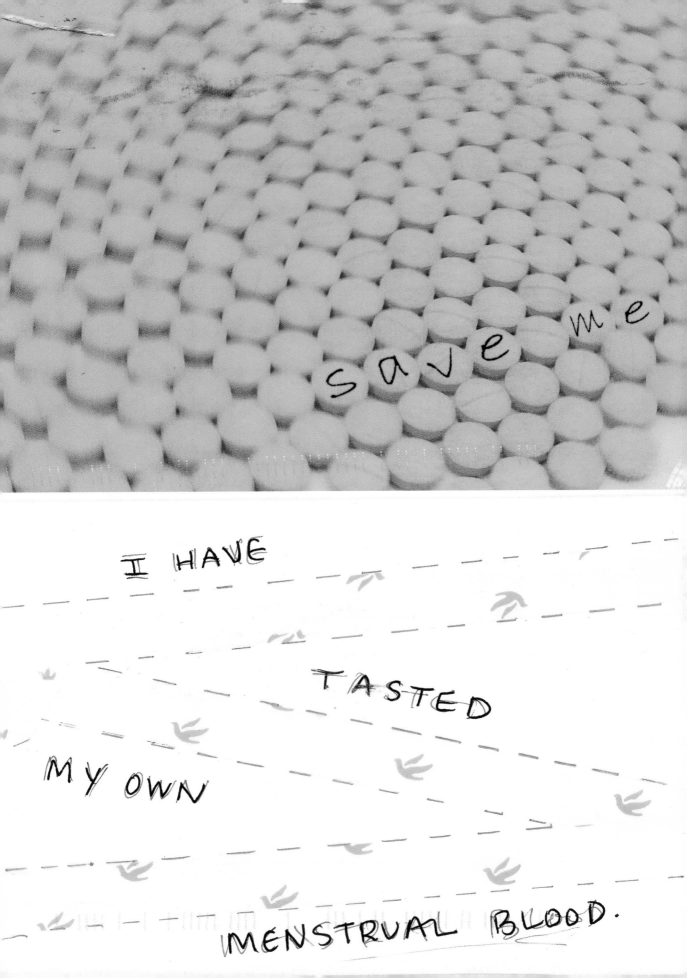

save me

I HAVE

TASTED

MY OWN

MENSTRUAL BLOOD.

MY FIRST CRUSH WAS A DISTANCE RUNNER.

WHENEVER I DRIVE BY SOMEONE JOGGING, I SLOW DOWN TO SEE IF IT'S HER.

SOMETIMES WHEN I'M ALONE...

I PRETEND I'M FAMOUS

and

BEING INTERVIEWED by -CONAN- -O'BRIEN-

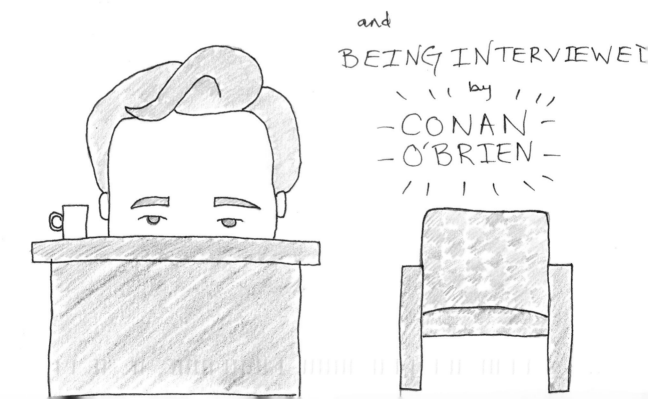

At a bridal shower, the bride-to-be opens a box containing a wine glass. Everyone gushes about how gorgeous it is. I look around and wonder if there's some connection between me being the only single girl there and secretly shouting inside my head, "It's a glass! It's made of glass! It's not gorgeous, it's glass!" What do they see that I don't?

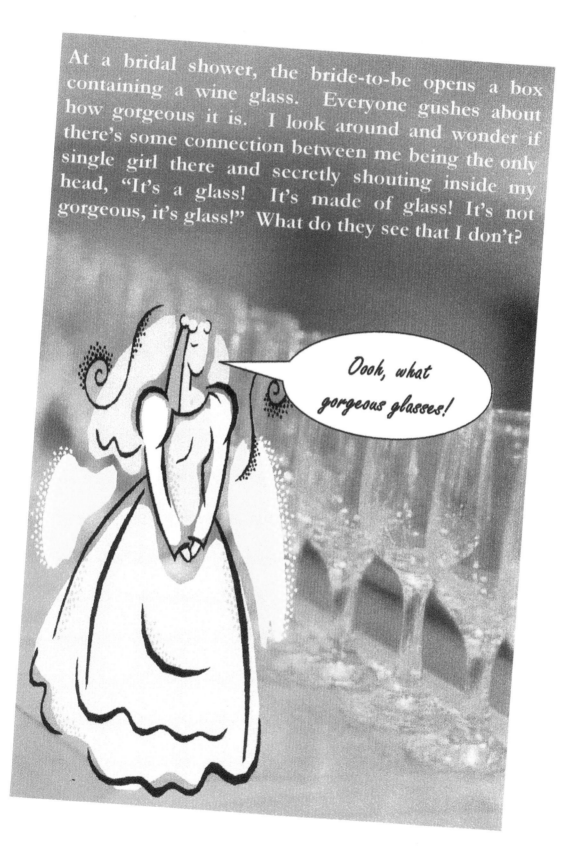

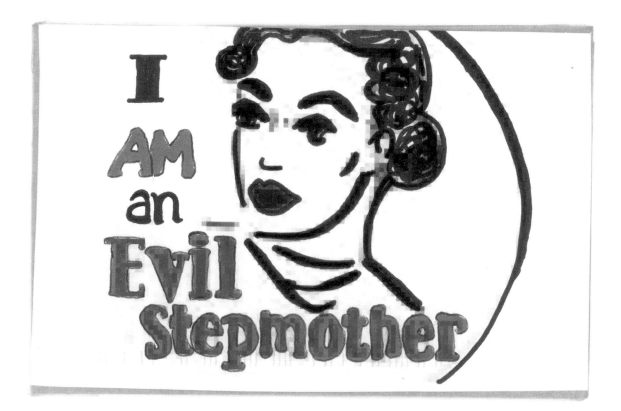

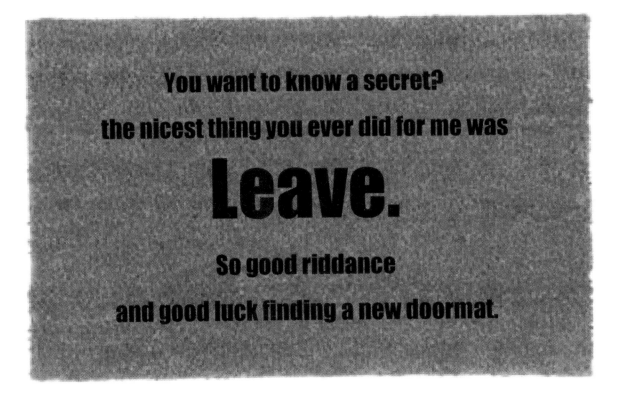

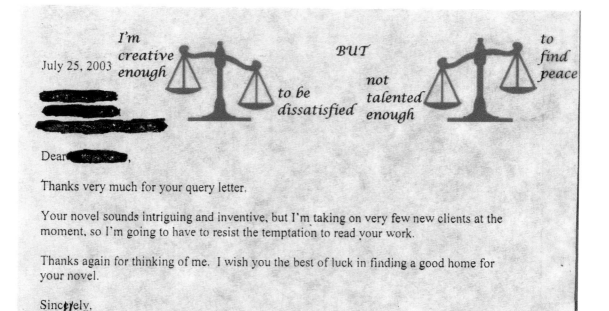

July 25, 2003

I'm creative enough | to be dissatisfied | **BUT** | not talented enough | to find peace

██████
██████
██████

Dear ████████,

Thanks very much for your query letter.

Your novel sounds intriguing and inventive, but I'm taking on very few new clients at the moment, so I'm going to have to resist the temptation to read your work.

Thanks again for thinking of me. I wish you the best of luck in finding a good home for your novel.

Sincerely,

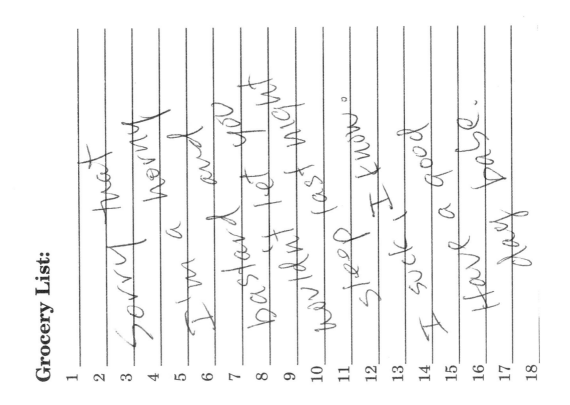

Grocery List:

1.
2.
3. Sorry that
4. your novel
5. I'm a
6. pass
7. bastard let you
8. down (last night)
9.
10. stead I know
11. sick a good
12. I have a house.
13.
14.
15.
16.
17.
18.

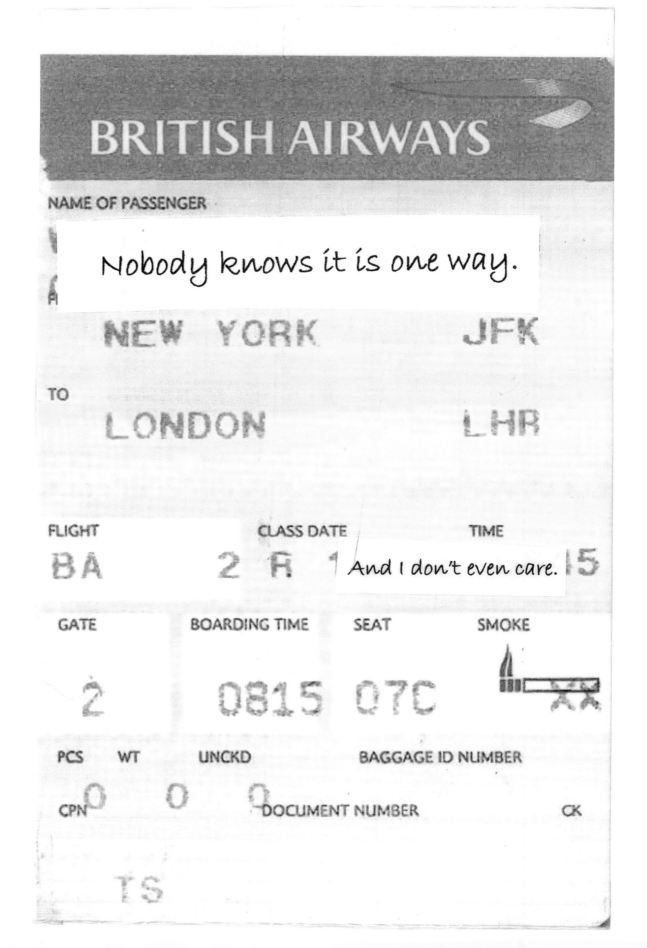

i know people are staring at my FAT ASS

My mother asked me to help her die when she couldn't stand the pain anymore – but I couldn't

Then she died suddenly and I was so relieved that I wouldn't have to

I Do it for the love of the Game
I Do it in respect of the players
I Do it because Im good at it

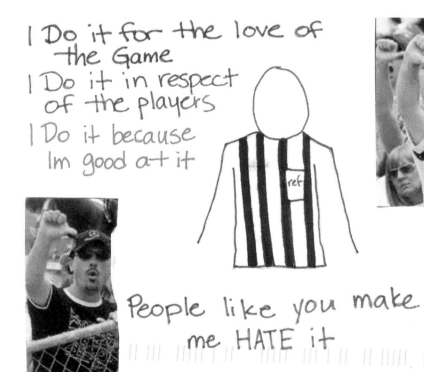

People like you make me HATE it

Sometimes I find a reason to go to the post office
just so I can get a milkshake from
the ice cream parlor next door,
and I don't bring any home for the kids.

In fact, mailing this postcard will be a great
reason to try out the newest flavor!

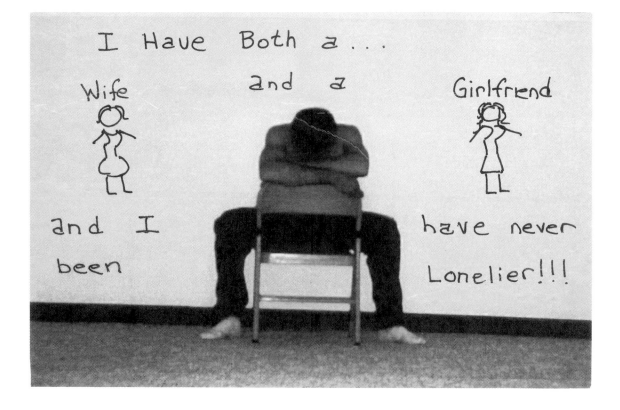

I haven't forgiven my dad for leaving when I was a kid. I'm 30 now and still feel he left because of me.

Google™

...and no one would believe me if i told them

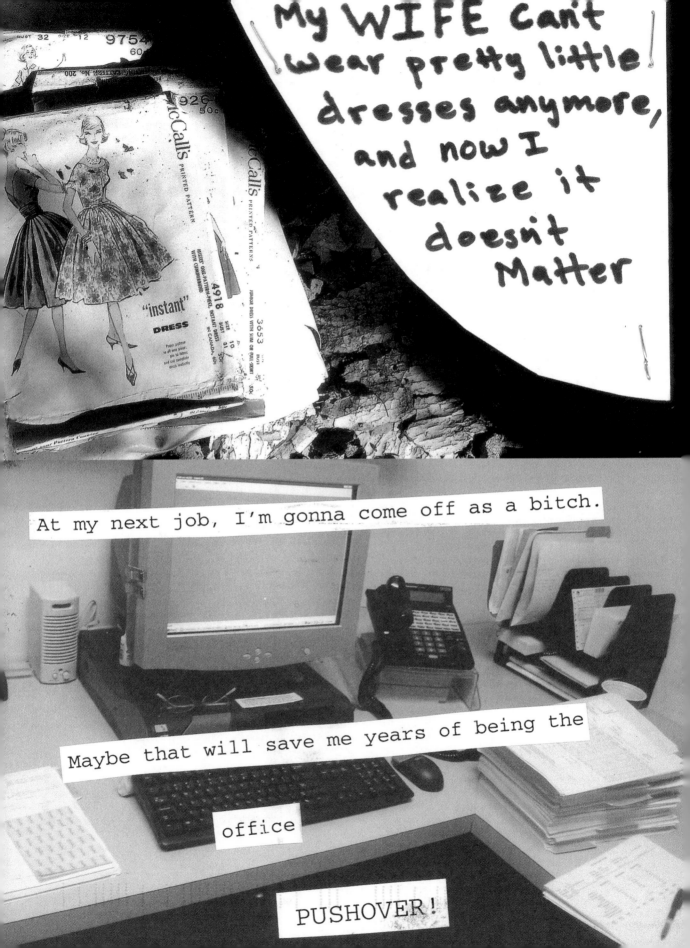

My WIFE can't wear pretty little dresses anymore, and now I realize it doesn't Matter

At my next job, I'm gonna come off as a bitch.

Maybe that will save me years of being the

office

PUSHOVER!

Sometimes, in the middle of the night, I wake up and feel like I'm going to sob uncontrollably because I'm so terrified of losing my job. I can't tell my wife because I don't want to scare her.

– Canada

On Thursday, I enjoyed dropping my postcard into the post office box and watching it disappear. My secret does not own me anymore. I don't need revenge.

– California

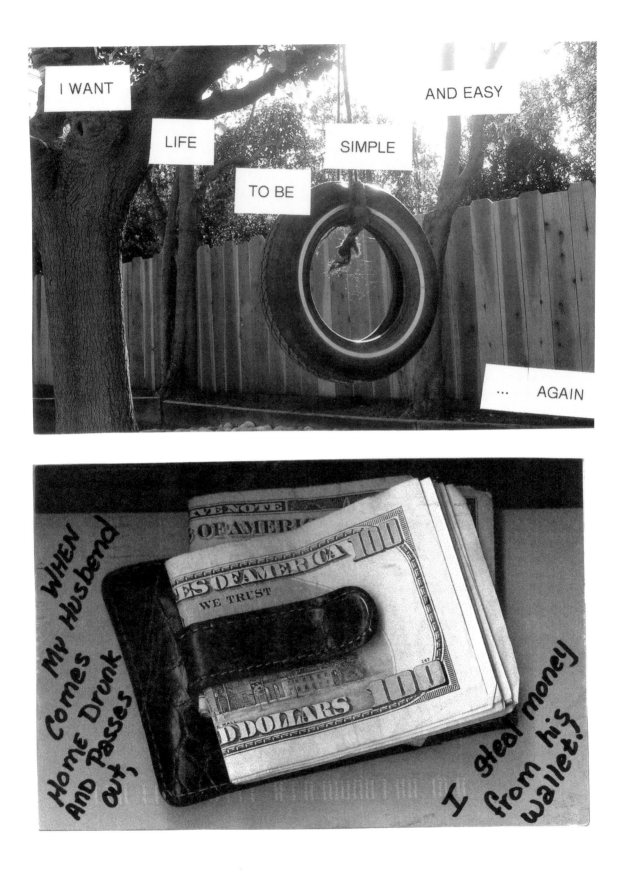

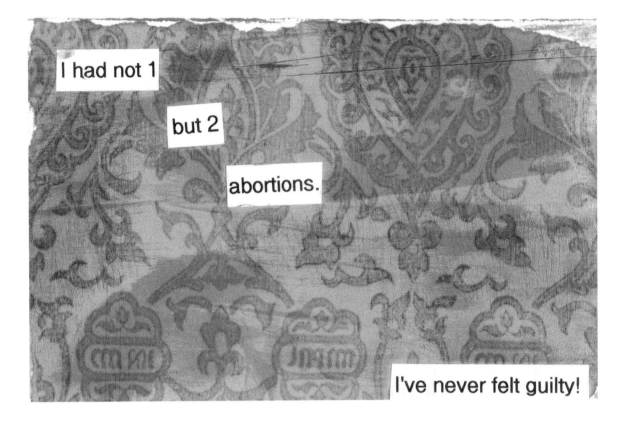

I had not 1

but 2

abortions.

I've never felt guilty!

i have two master's degrees

and a doctorate...

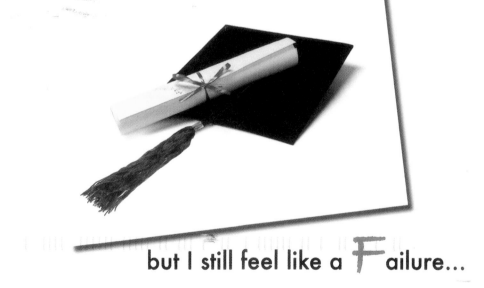

but I still feel like a Failure...

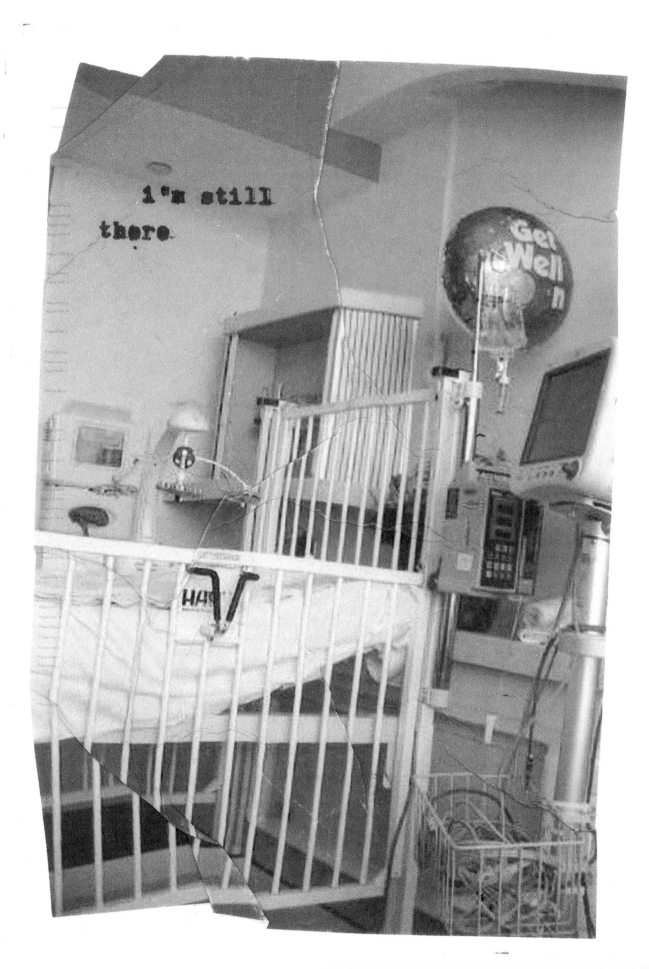

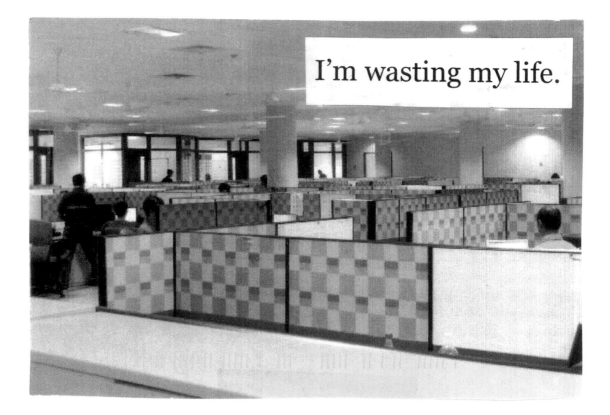

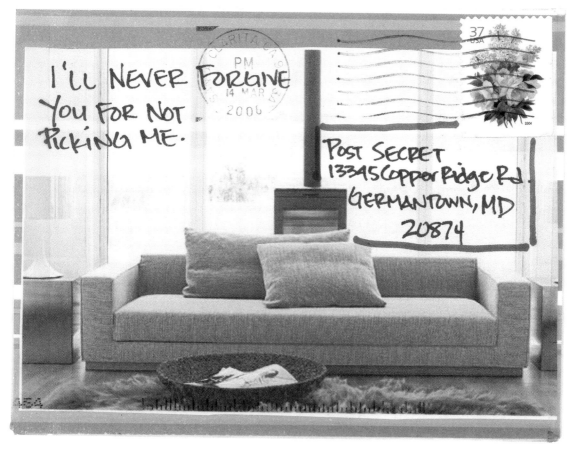

i want to watch my wife make love with another man

Top ten reasons I prefer attending funerals over weddings:

10. Nobody obliges you to dance, drink alcohol or eat leftovers.
9. Cemeteries are nicer meeting places than the insides of churches or reception halls, even in winter.
8. You're not expected to say anything to the "honored," only offer condolences to their friends and family.
7. There is no expectation of gifts, only a card and consolation.
6. Funerals are (generally) quieter, without loud music. People are also mo willing to listen so communication is possible.
5. They're shorter, so I can use the day for other things too.
4. There is no months-long countdown placing pressure to make it the "bes day in their life."
3. Nobody has to act like "it will work out," since it always does.
2. I'm not expected to pretend that I'm having a good time.
1. Nobody will ever ask "so when do you think it will be your turn?"

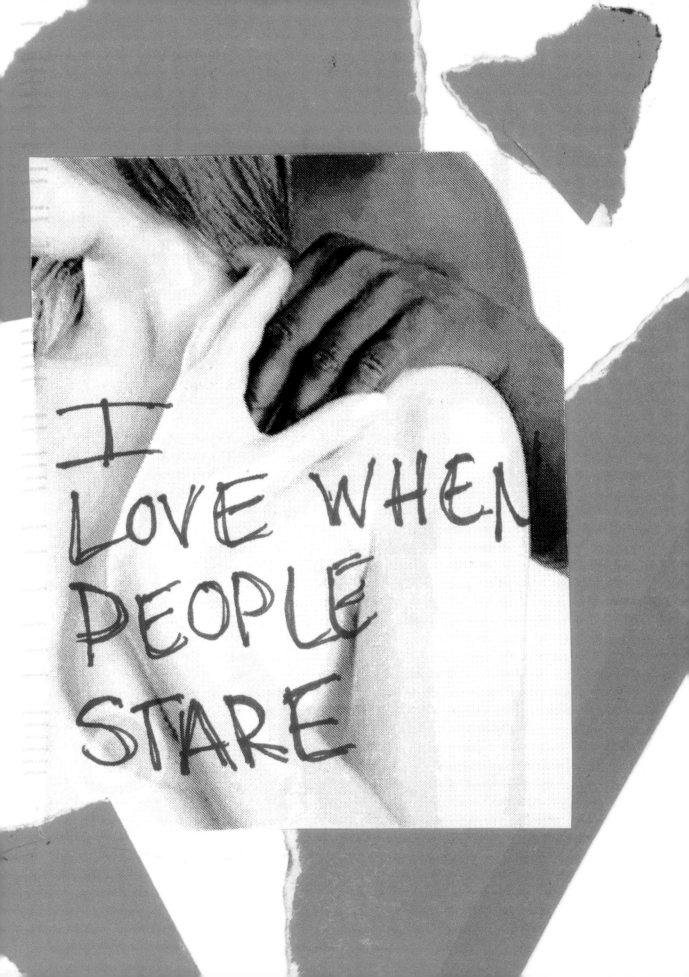

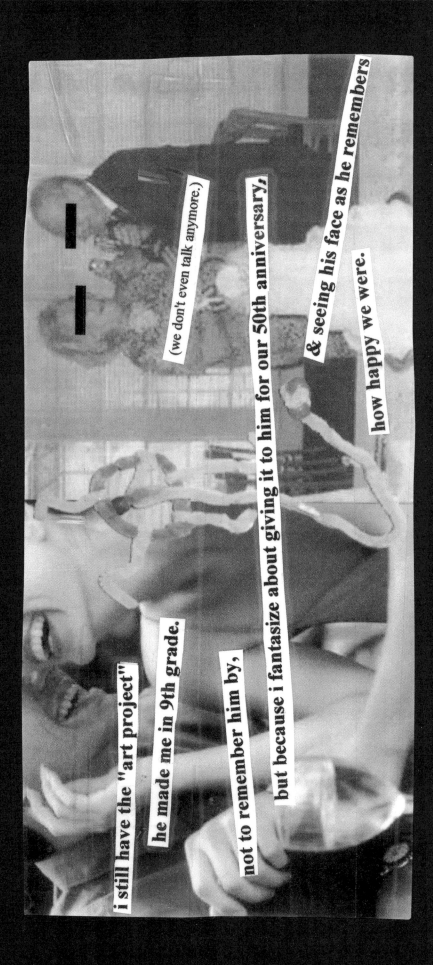

i still have the "art project"

he made me in 9th grade.

(we don't even talk anymore.)

not to remember him by,

but because i fantasize about giving it to him for our 50th anniversary,

& seeing his face as he remembers

how happy we were.

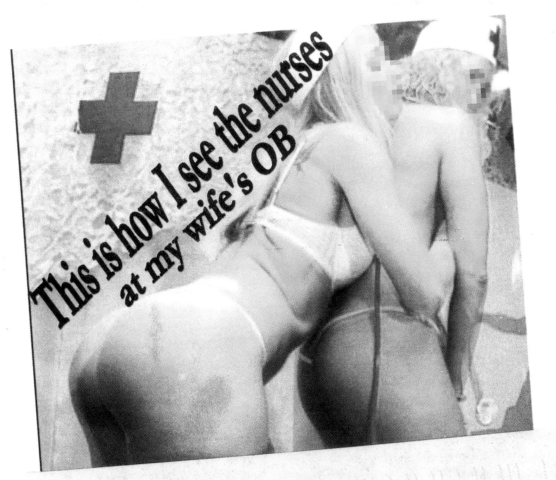

This is how I see the nurses at my wife's OB

every vacation i sneak out and go skinny- dipping

i wish i knew how

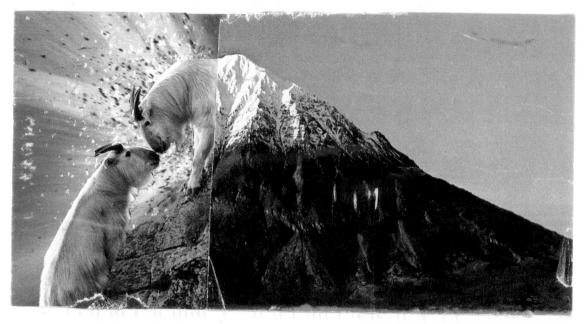

to give up on you

worry
i ~~believe~~ there
is no love
for me.
(when I wrote
"believe" I
realized I still
had a little hope.)

every year on june 4th

i slow dance

alone

to the same song....

while pretending to hold

the baby

i miscarried

I can only write poetry when I feel sad and alone...
I havn"t written a poem in over two years

ASK ME, I'LL COME

I can't believe I let you define
our relationship

without putting up a ~~better~~ fight.
~~bigger~~
any

my bad. our loss.

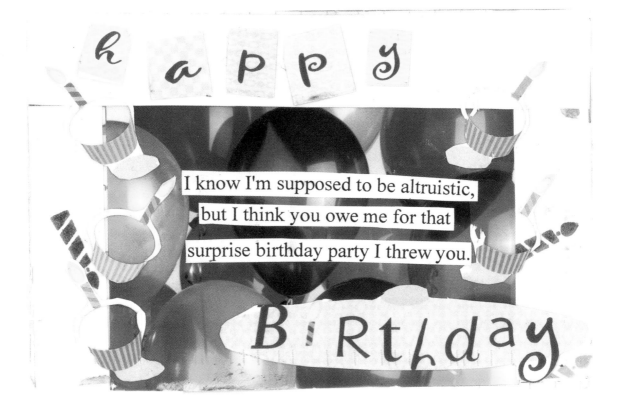

happy

I know I'm supposed to be altruistic, but I think you owe me for that surprise birthday party I threw you.

BiRthday

I INTENTIONALLY SCREW UP MY COMPUTER SO THAT MY HUSBAND'S FRIEND COMES OVER TO FIX IT ...

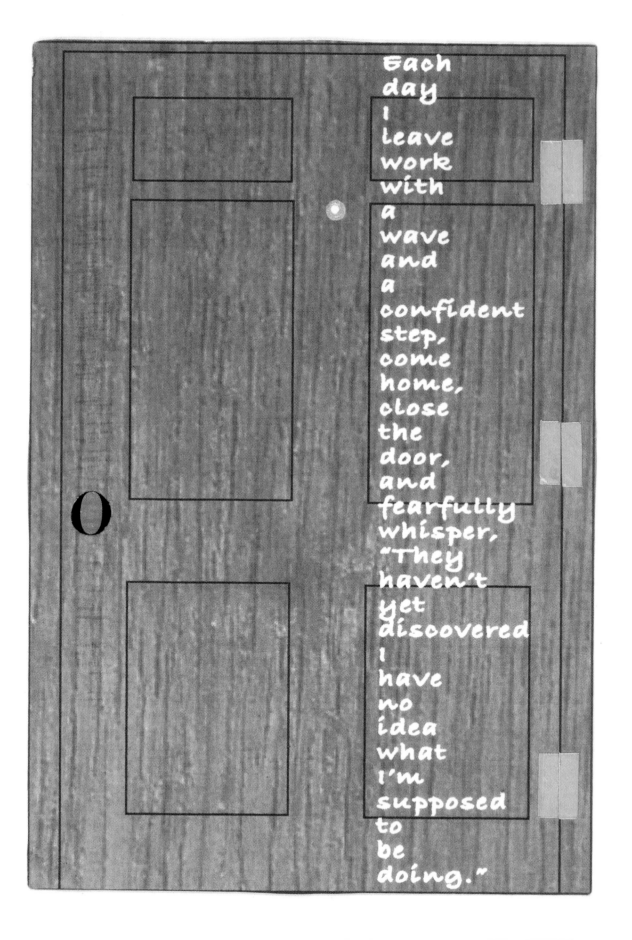

Each day I leave work with a wave and a confident step, come home, close the door, and fearfully whisper, "They haven't yet discovered I have no idea what I'm supposed to be doing."

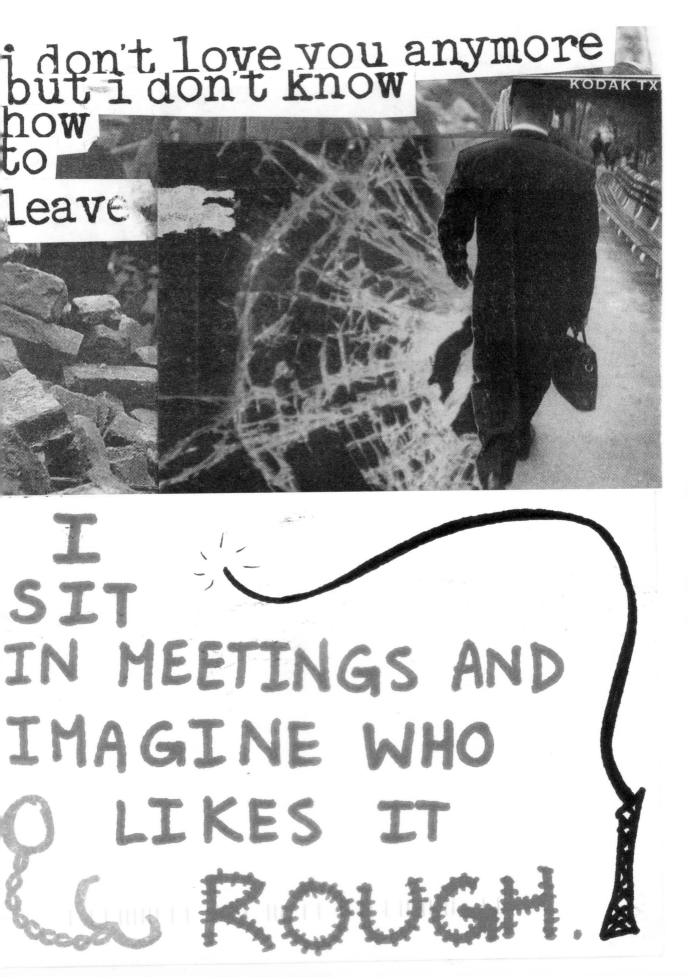

i don't love you anymore
but i don't know
how
to
leave

I
SIT
IN MEETINGS AND
IMAGINE WHO
LIKES IT
ROUGH.

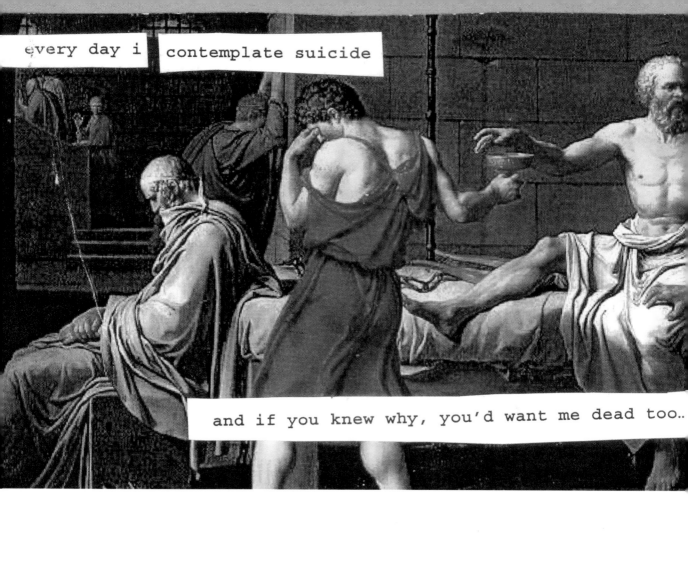

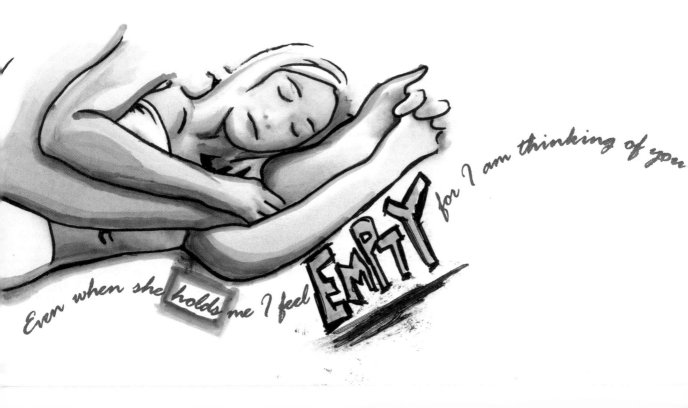

All of my ex's

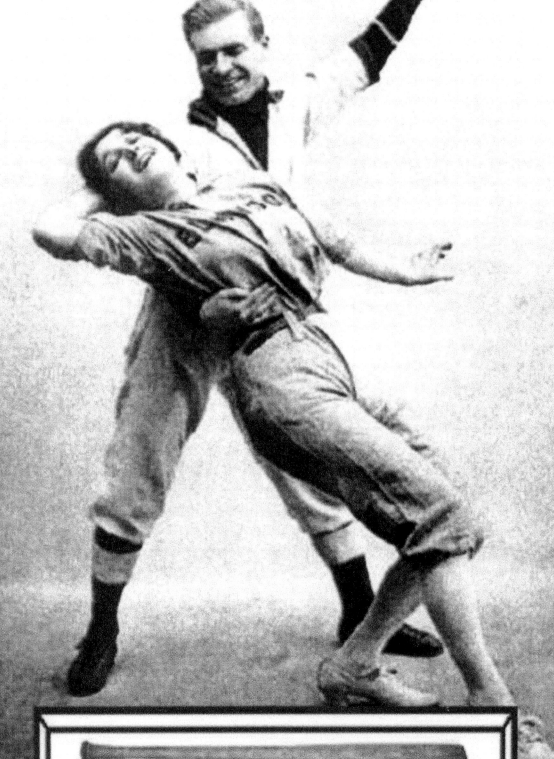

BAT FOR THE OTHER TEAM

I HAVEN'T BROUGHT ANY OF MY FRIENDS TO MY HOUSE IN 10 YEARS BECAUSE I LIVE IN A HOTEL AND AM ASHAMED OF IT.

have other women made this decision so easily?

i knew immediately.

(which is kind of weird.)

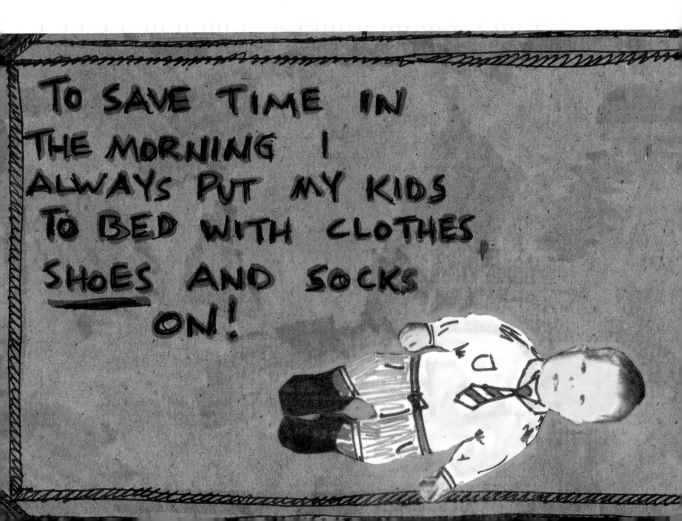

TO SAVE TIME IN
THE MORNING I
ALWAYS PUT MY KIDS
TO BED WITH CLOTHES,
SHOES AND SOCKS
ON!

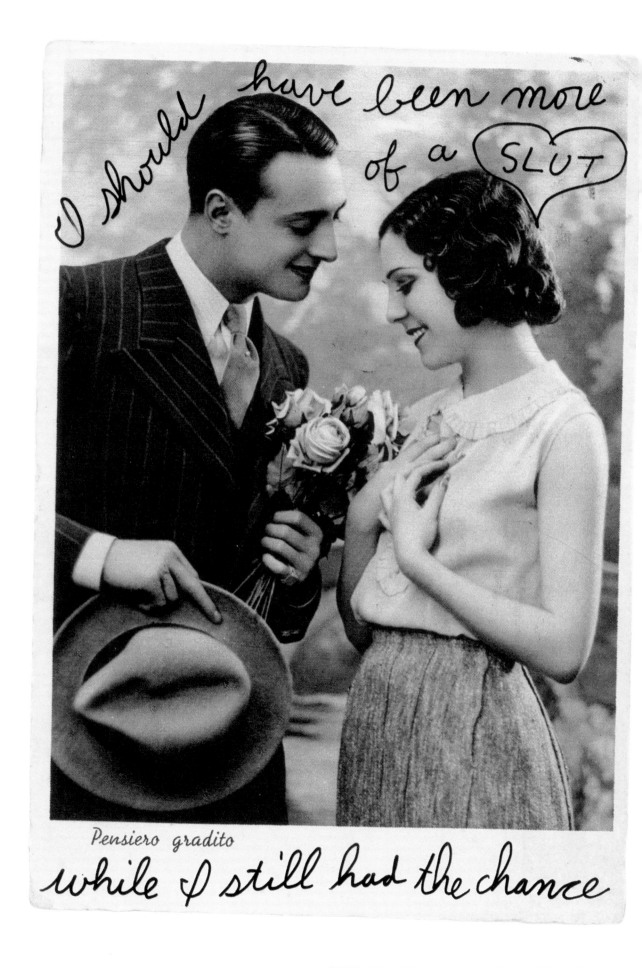

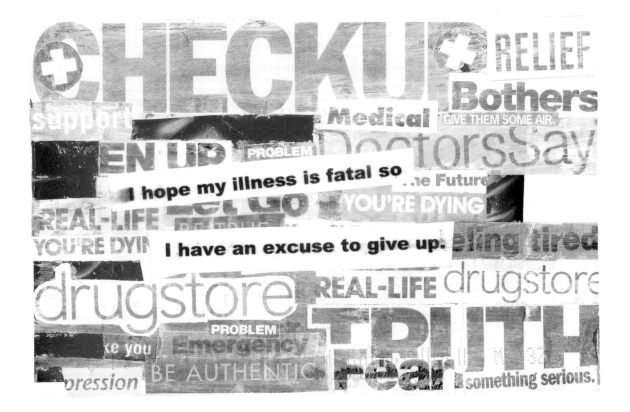

CHECKU ✚RELIEF
support ✚Medical Bothers GIVE THEM SOME AIR.
EN UP PROBLEM DoctorsSay
I hope my illness is fatal so ...he Future
REAL-LIFE Let GO YOU'RE DYING
YOU'RE DYIN I have an excuse to give up. eling tired
drugstore REAL-LIFE drugstore
PROBLEM TRUTH
ke you Emergency
pression BE AUTHENTIC Fear something serious.

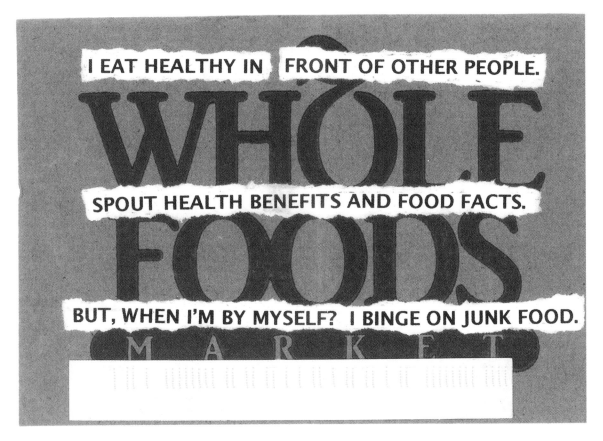

I EAT HEALTHY IN FRONT OF OTHER PEOPLE.

WHOLE

SPOUT HEALTH BENEFITS AND FOOD FACTS.

FOODS

BUT, WHEN I'M BY MYSELF? I BINGE ON JUNK FOOD.

MARKET

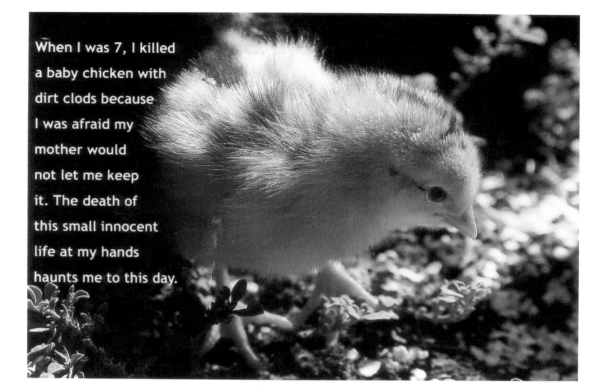

When I was 7, I killed a baby chicken with dirt clods because I was afraid my mother would not let me keep it. The death of this small innocent life at my hands haunts me to this day.

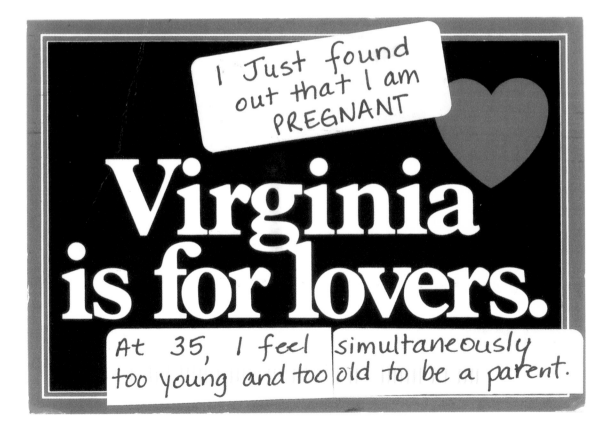

I Just found out that I am PREGNANT

Virginia is for lovers.

At 35, I feel simultaneously too young and too old to be a parent.

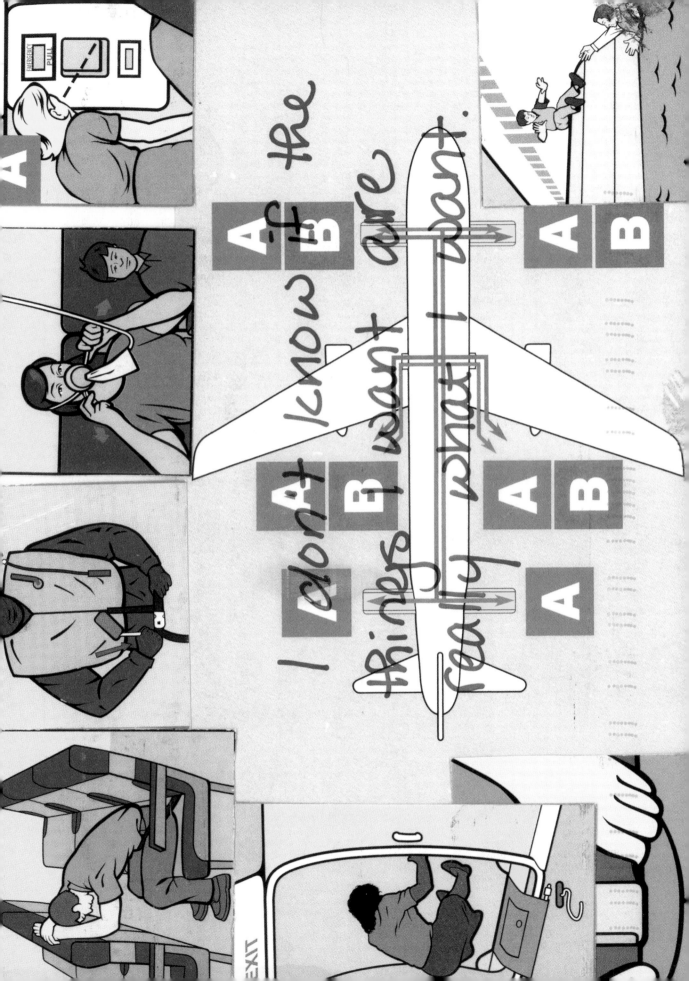

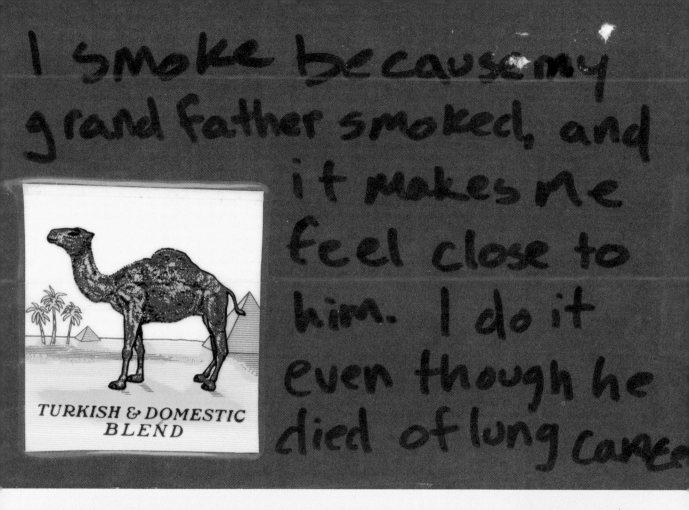

I smoke because my grandfather smoked, and it makes me feel close to him. I do it even though he died of lung cancer

TURKISH & DOMESTIC
BLEND

I complain about the 70's-era brown linoleum floor in my kitchen, but I secretly think it serves a good purpose.....

I have not washed my kitchen floor in over 5 years.

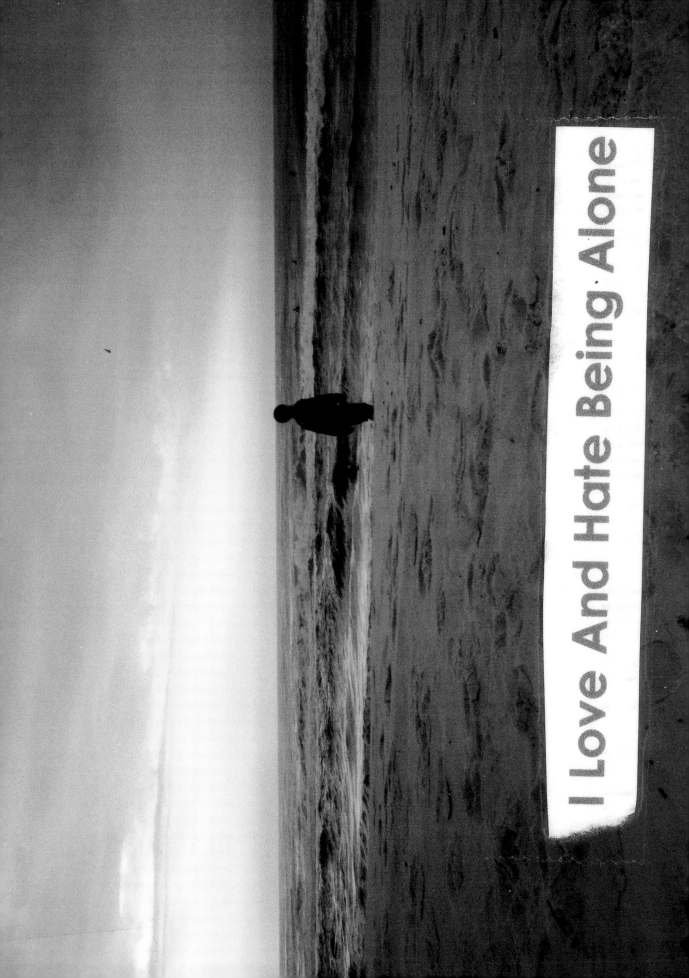

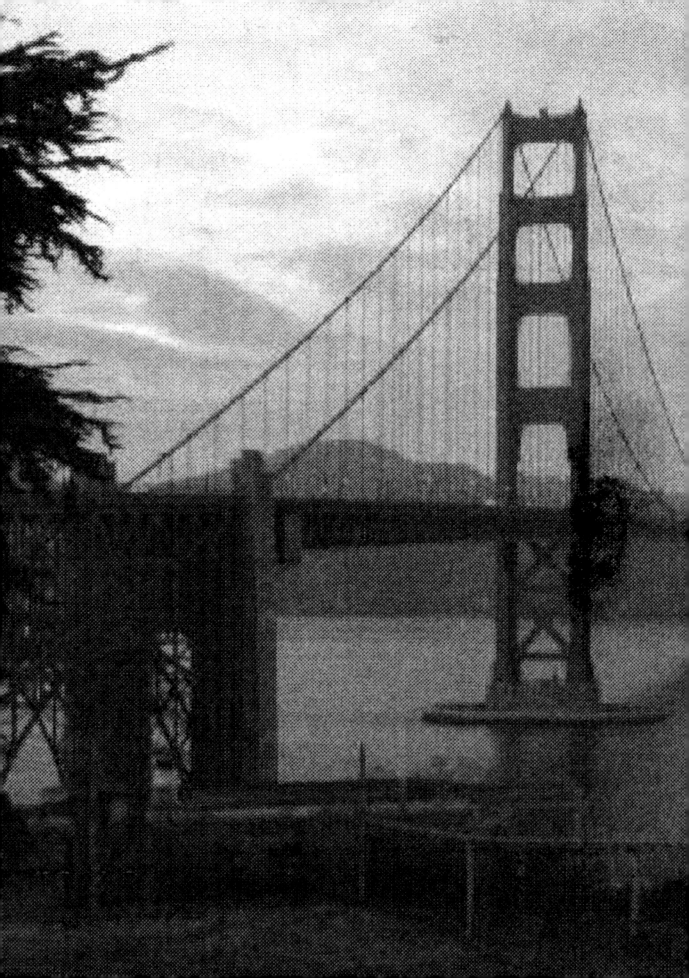

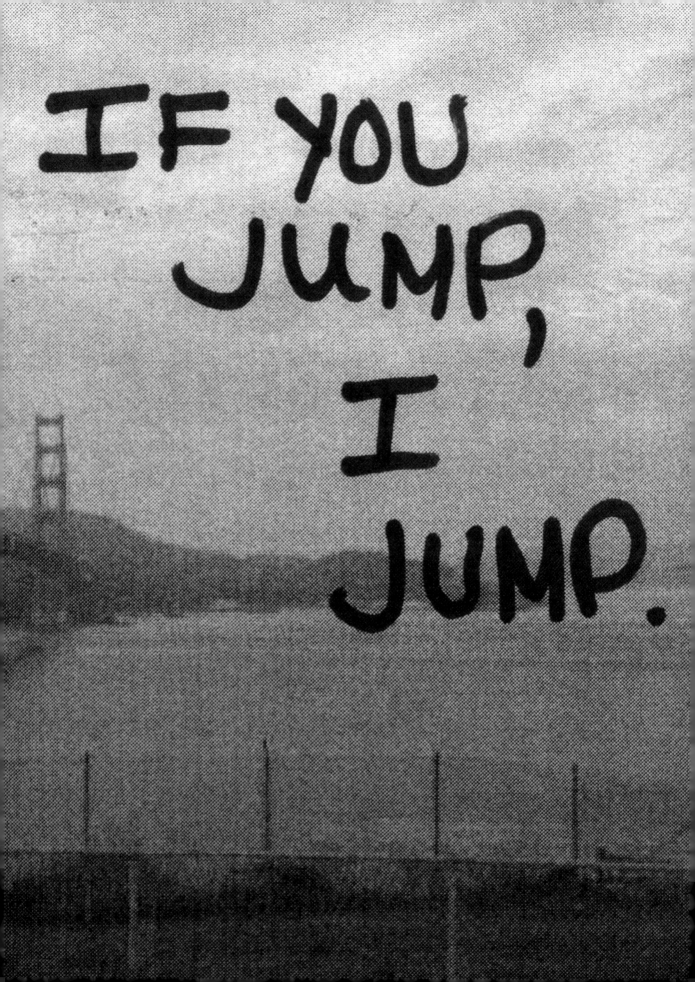

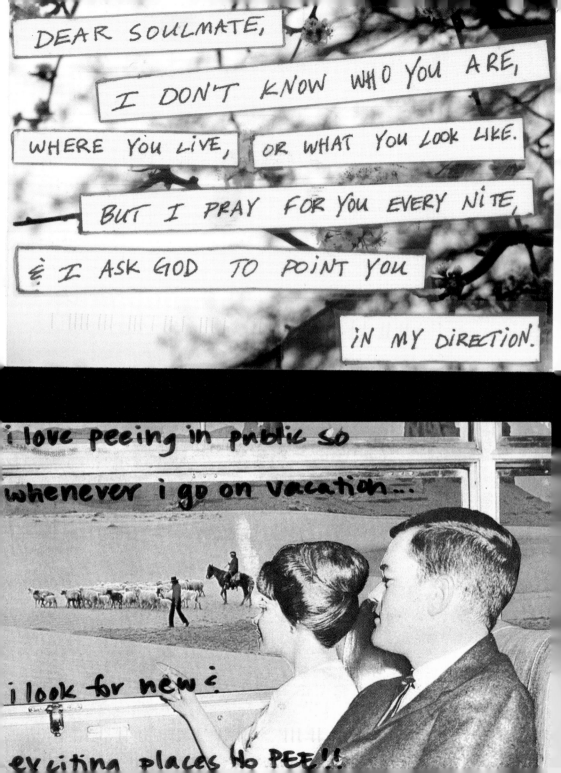

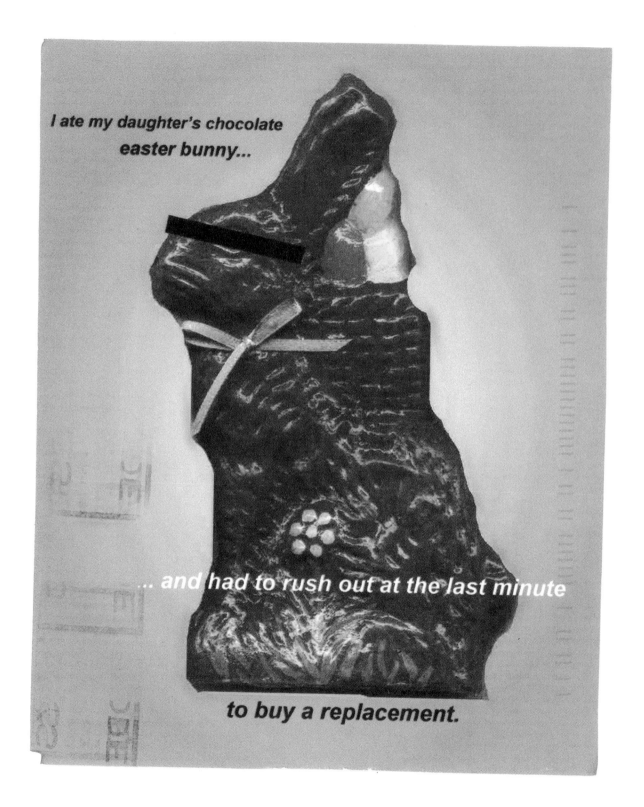

When I was young I used to hate my body…

Now that I'm older, I know better. I'm HOT!

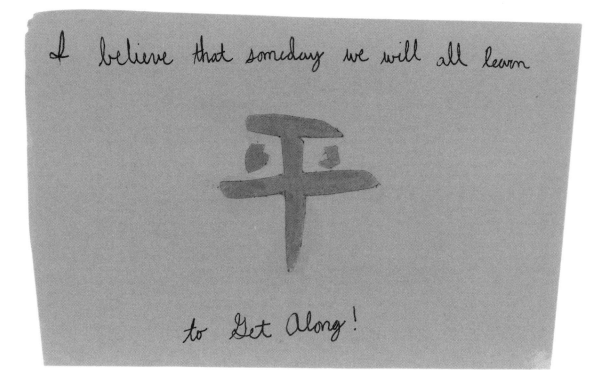

I believe that someday we will all learn

平

to Get Along!

I have felt some relief since I switched
from acting to office work
for a living.

And the sadness isn't devastating.

My wife says she's seen smaller...

ARMOUR ★
VIENNA SAUSAGE
MADE WITH CHICKEN, BEEF & PORK IN BEEF STOCK

SERVING
SUGGESTION

AMERICA'S
FAVORITE

NET WT
5 OZ
(142g)

But I think she's just being kind.

I long to go fishing

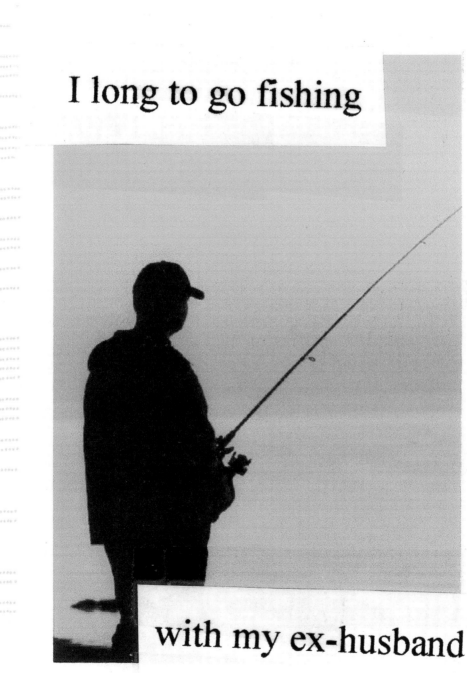

with my ex-husband

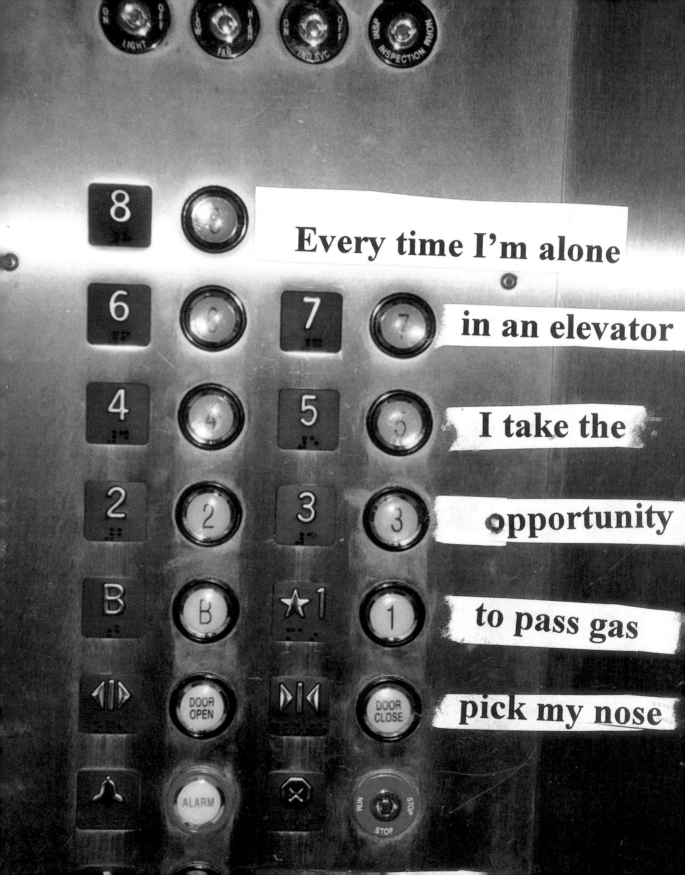

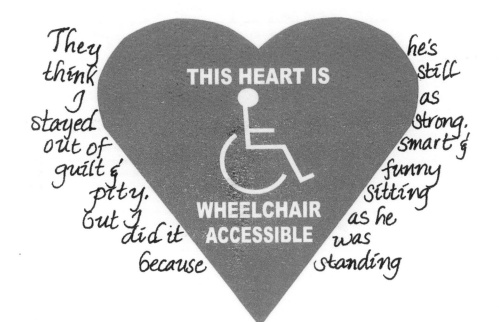

They think I stayed out of guilt & pity. but I did it because

THIS HEART IS WHEELCHAIR ACCESSIBLE

he's still as strong, smart & funny sitting as he was standing

... it's also why I asked him to marry me.

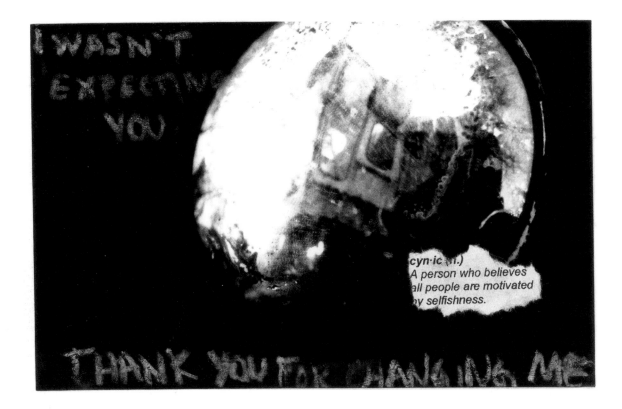

I WASN'T EXPECTING YOU

cyn·ic (n.)
A person who believes
all people are motivated
by selfishness.

THANK YOU FOR CHANGING ME

SEPARATED BY ROUTINE

WE ARE ALL

MOURNING IN
PARALLEL
FORM

THE SAME SILENT
TRAGEDIES

FRANK WARREN is a small business owner who started PostSecret as a community art project. Since November 2004, Warren has received thousands of anonymous postcards, which have been featured in galleries, a traveling art exhibit, the popular music video for the All-American Rejects' "Dirty Little Secret," and, most recently, in the bestselling books *PostSecret* and *My Secret.* Ranked by *New York* magazine as the third most popular blog on the Internet, Warren's website earned several awards at both the 2006 Bloggy and Webby Awards and continues to attract over 3 million visitors a month. Warren has appeared on *Today, 20/20*, CNN, MSNBC, NPR, and Fox News, among others. Warren lives in Germantown, Maryland, with his wife and daughter.

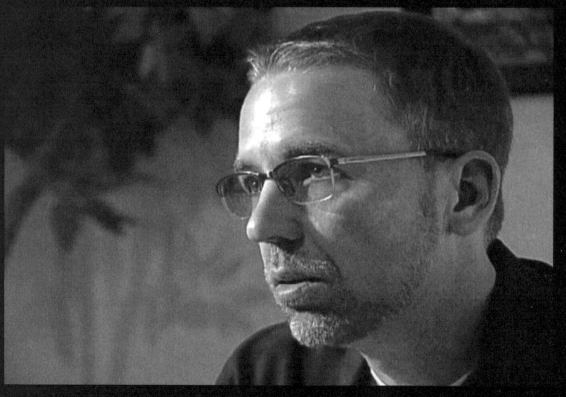

www.postsecret.com

To receive notice of author events and new books
by Frank Warren, sign up at www.authortracker.com.